Published in Great Britain, the USA and Canada in 2019
by Canongate Books Ltd, 14 High Street, Edinburgh EH1 1TE

Distributed in the USA by Publishers Group West and in Canada by
Publishers Group Canada

First published in the USA by McSweeney's Books in 2006

canongate.co.uk

1

British Library Cataloguing-in-Publication Data
A catalogue record for this book is available on
request from the British Library

ISBN 978 1 78689 950 7

Drawings courtesy
Pace/MacGill Gallery NYC
pacemacgill.com

Design: DB + Danielle Spencer

Printed and bound in Italy by LEGO S.p.A.

ARBORETUM

David Byrne

CANONGATE

Contents

Arboretum Again

Introduction to the 2019 edition

One of the biggest thrills I've experienced was when I spotted this book in the philosophy section of Ada's Technical Books in Seattle. "They get it!" I thought to myself. Or someone has a sense of humor. It makes me happy that this book is being reissued; this tells me some folks find it useful as well as sometimes being funny.

We know that correlation is not causation, but it's also true that there are times when unexpected similarities of patterns and initially dubious connections, often across disciplines, can enable us to think and imagine outside the typologies and categories that have developed over time. Although many of these cladograms might seem a bit far-fetched, they are often no less surprising than some of the discoveries and conjectures I have read about since this book first came out in 2006.

That time is a construct and it flows both backwards and forwards. That trees talk to one another through an underground network and that they protect one another. That religious children tend to be less kind and meaner to strangers. That music often does mirror cosmic relationships – or could it be the other way around?

These drawings came in a burst, a flood, and I can only think that something in my life, some context at that particular time, inspired me to think and explore by drawing at that moment. I have no idea what I might have been going through that drove my hand to move, but I seem to have intuited that drawing was the tool best suited for the job.

These are a kind of visual glossolalia, an attempt to explore the world beyond logic. I see them as, paradoxically, a non-verbal language that uses words to break their own stranglehold on us.

We have a built-in urge to make sense of the world, to presume cause and effect and to endorse and internalise the categories that we have inherited. Some of the existing established connections we have inherited may be or might have been useful, and they stuck, but looking back it now seems that as I drew these I must have been at a place in my life when I was asking, "what if there's another way? What would it be like if the categories were not *those* ones, but some other organizational system? What might that be like? And then which one is true?"

Categories are a prison that condemns us to see things and each other in particular ways. Medicine and much of science used to be considered arts, but they were forcibly divorced, though as any mathematician or surgeon will tell you, deep down they are still arts. That separation may have had its uses but it also arrested the flow of many innovative ideas. This prison is one we have built ourselves, because it can be convenient and useful; at least it is at the moment each category and connection comes into being, but what might life be like on the outside?

—DB
New York, 2019

Why?

What are these drawings?

Why did I do them?

Will they be of interest to anyone else?

Of any use?

Do they need to be useful?

Well, I guess they're a lot of things. Faux science, automatic writing, self-analysis, satire and maybe even a serious attempt at finding connections where none were thought to exist. And an excuse to draw plant-like forms and diagrams.

They began a few years ago as instructions to myself in a little notebook—"draw an evolutionary tree on pleasure," or "draw a Venn diagram about relationships," for example. Commands to myself to make mental maps of imaginary territory. These accumulated over a few years until the impulse was spent. Maybe it was a sort of self-therapy that worked by allowing the hand to "say" what the voice could not.

Irrational logic—I've heard it called that. The application of logical scientific rigor and form to basically irrational premises. To proceed, carefully and deliberately, from nonsense, with a straight face, often arriving at a new kind of sense.

But how can nonsense ever emerge as sense? No matter how convoluted or folded, it will still always be nonsense, won't it?

I happen to believe that a lot of scientific and rational premises are irrational to begin with—that the work of much science and academic inquiry is, deep down, merely the elaborate justification of desire, bias, whim, and glory. I sense that to some extent the rational "thinking" areas of our brains are superrationalization engines. They provide us with means and justifications for our more animal impulses. They allow us to justify them both to ourselves and then, when that has been accomplished, to others. "The hope that a mathematically unique solution will emerge [as an explanation of nature] is as faith-based as intelligent design," says Leonard Susskind, inventor of string theory.

This might not seem like a very optimistic perspective on intelligence, but even viewed this cynically, the result of centuries of this cerebral activity has produced a lot of beauty, pleasure, and magnificent, well, stuff.

I watched a nature documentary on my laptop with my daughter on a train today, and we saw creatures from the ocean's depths caught in the glow of deep-sea submersibles. Some of the creatures had never been seen before, or were not even thought possible. Things that spew time-delay fireworks, things that live where life was thought to be impossible, undersea "lakes", a fish on a kind of stalk. Well, we both agreed that they would have seemed preposterous, imaginary, and unbelievable, if the camera hadn't filmed them.

So, extrapolating from Mother Nature, if you can draw a relationship, it can exist. The world keeps opening up, unfolding, and just when we expect it to be closed—to be a sealed sensible box—it shows us something completely surprising. In fact, the result and possibly unacknowledged aim of science may be to know how much it is that we don't know, rather than what we do think we know. What we think we know we probably aren't really sure of anyway. At least if we can get a sense of what we don't know, we won't be guilty of the hubris

of thinking we know any of it. Science's job is to map our ignorance.

Some of the typologies I've drawn on—wine descriptions, East Village clubs and bars, medieval war machines—are terms that are possibly obscure. Therefore I've written some paragraphs that might give a hint as to what these names, classifications, typographies and categories refer to; these explanations will either illuminate my intentions or simply annoy.

Lawrence Weschler, in his recent book *Everything That Rises: A Book of Convergences* begins to ask where these connections come from. He asks if the similarities in the branching structures of neurons, trees and genealogies mean that we have a predisposition towards making things fit these structures. Do we see that which we are? Is that both the limit and form of our perception? Do we rule out other ways of mapping and organizing as a result? And if this is true, how does a structural pattern evolve to become a way of seeing and thinking?

I think these connections go even further. I see recent news photos that (unintentionally?) mimic Caravaggios, others that look exactly like images from *Star Wars*, the body attitudes of the Loas of Vodou or of classical Greek sculpture. Postures, poses and perspectives keep recurring over and over. As if Jung's archetypes—characters, relationships and stories imbedded in our thoughts—unconsciously urge us not only to psychologically label situations and relationships, but also to gravitate towards certain images and specific angles in our image choices. The picture editor in our heads. I don't think every photojournalist, for example, has a childhood memory of classical art that they once saw on a school trip that they use as an unconscious reference, though some might. I think rather the journalists and the classical artists are more likely drawing on the same deep internal sources. Here indeed is intelligent design.

By that I don't mean a far-off divine intelligence; I mean that the mental structures themselves, the trees and branches that predispose us to see things in certain ways, evolved over millions of years, are self-replicating and "intelligent."

So, here I am pencil in hand, poking around in the dark—wait, is it a pencil or a flashlight? ...that's it! The pencil *is* a flashlight, and it roughly illuminates a tiny part of the above "intelligence." Maybe just enough to get it all wrong, but the puzzle pieces are us—we can recognize familiar pieces of ourselves, and so they are scary, fascinating and lovable.

—DB
Manila and San Francisco, 2005

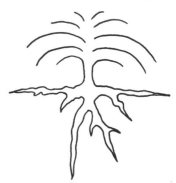

1. Psychological History

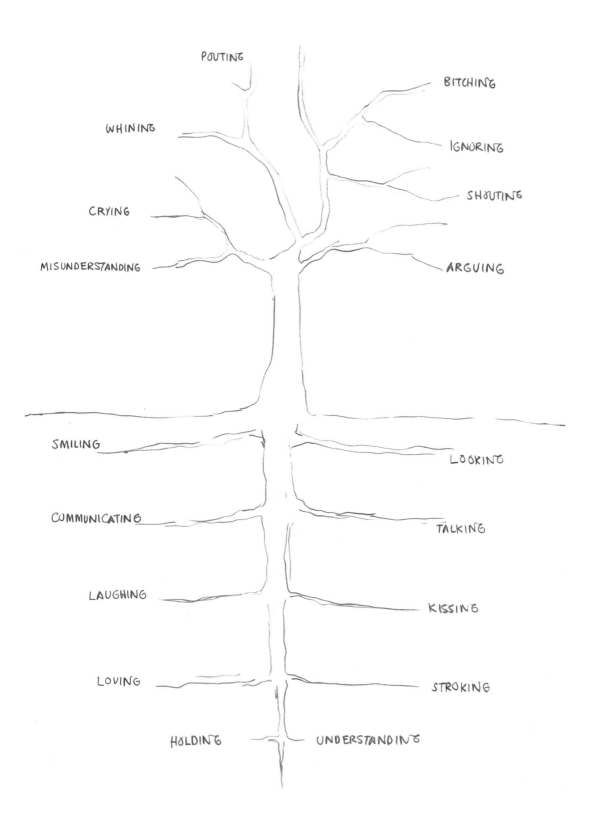

2. Taxonomical Transformations ⓘ

MOCK TUDOR

SPLIT LEVEL

COLONIAL

RANCH

A-FRAME

CHALET

NEW ENGLAND

CLASSICAL

MODERNE

CRULLERS

DONUTS

CROISSANTS

KAISER

BREAKFAST ROLLS

BAGELS

SCONES

BUNS

TARTS

3. Music of the Future

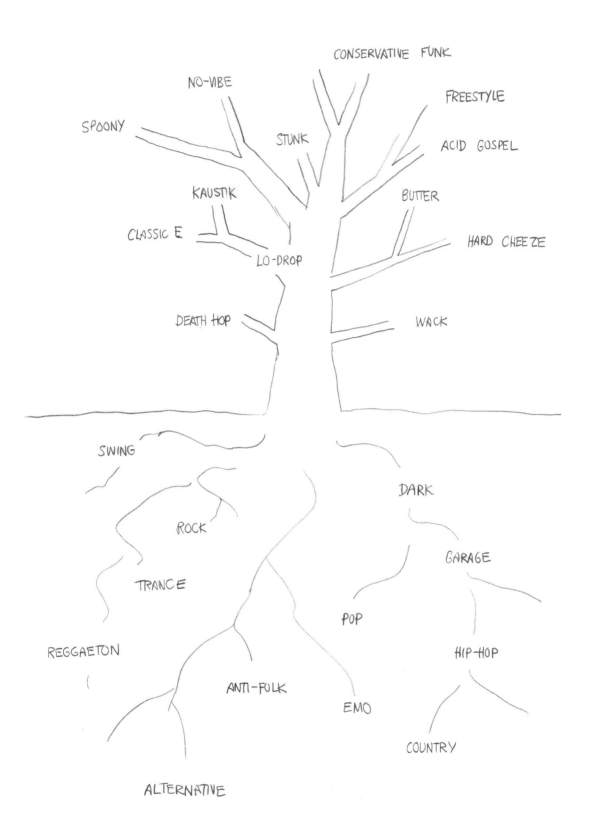

4. Pattern Recognition ⓘ

URBAN PLANNING

MUSICAL COMPOSITION

CHOREOGRAPHY

NANOTECHNOLOGY

MODERN ARCHITECTURE

DANDRUFF ON SHOULDERS

PIMPLE PATTERNS

STAR CONSTELLATIONS

GUM ON SIDEWALKS

MIGRATING BIRDS

SCHOOLS OF FISH

HAIR STUCK IN DRAINS

RANDOM SPILLS & STAINS

SUBATOMIC MOVEMENT

5. Hidden Roots ⓘ

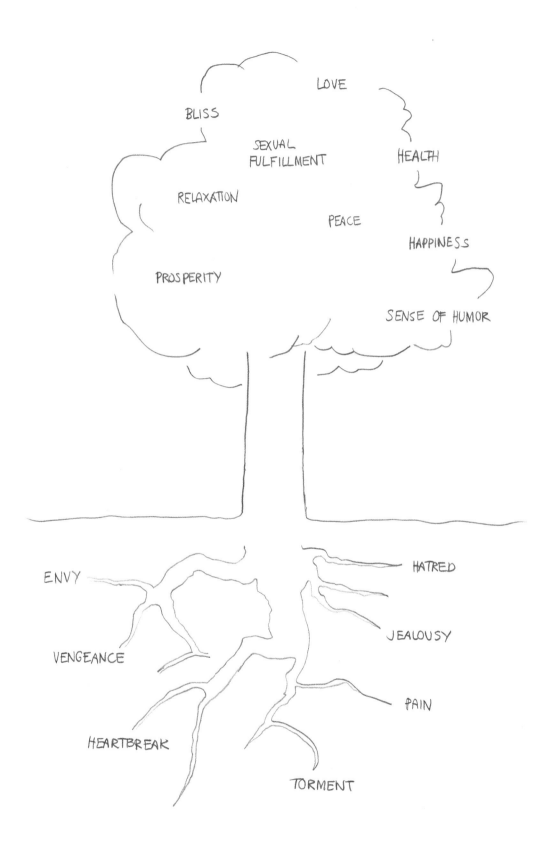

6. Human Content ⓘ

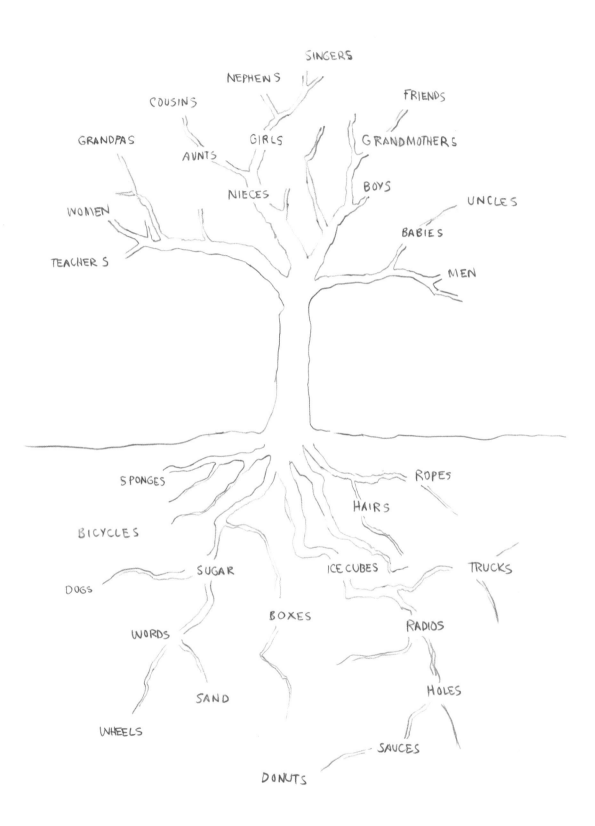

7. Morphological Transformations I ⓘ

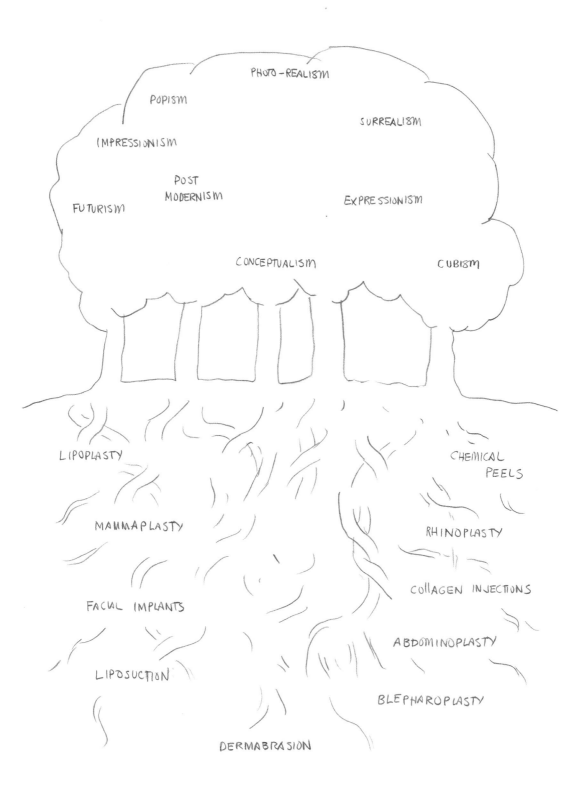

8. Yes Means No ⓘ

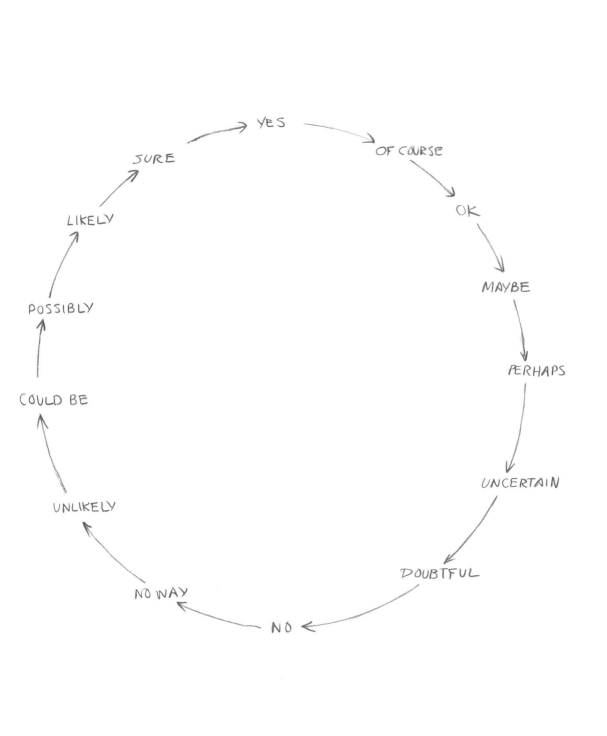

9. Christian Subcultures

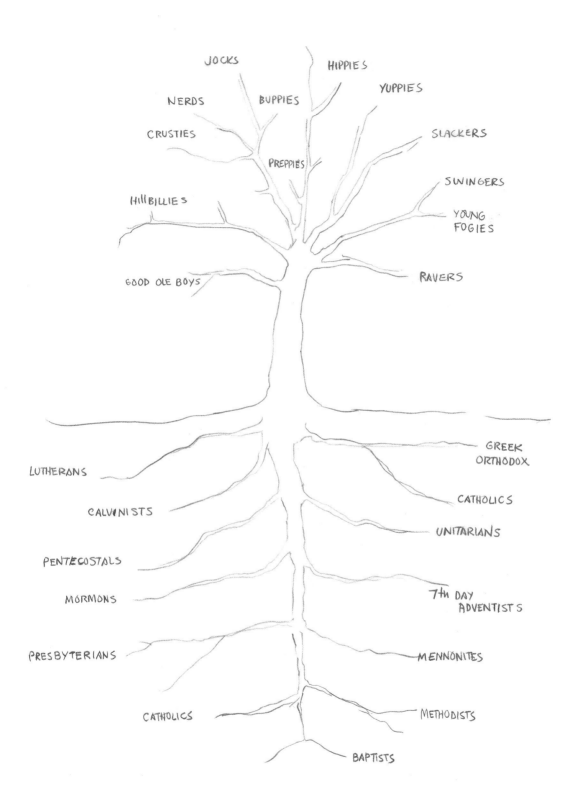

10. Social Information Flow

THE ONION

VILLAGE VOICE

CLUB FLYERS

TIME OUT

FREE DOWNLOADS

SEARCH ENGINES

IN-FLIGHT MAGAZINES

SHAREWARE

FILE SHARING

CLASS REUNIONS

POTLATCH CEREMONIES

PARADES

BARS

DINNER PARTIES

COSTUME DRAMAS

PICNICS

STRIP SHOWS

COMMUNISM

11. The Legacy of Good Habits

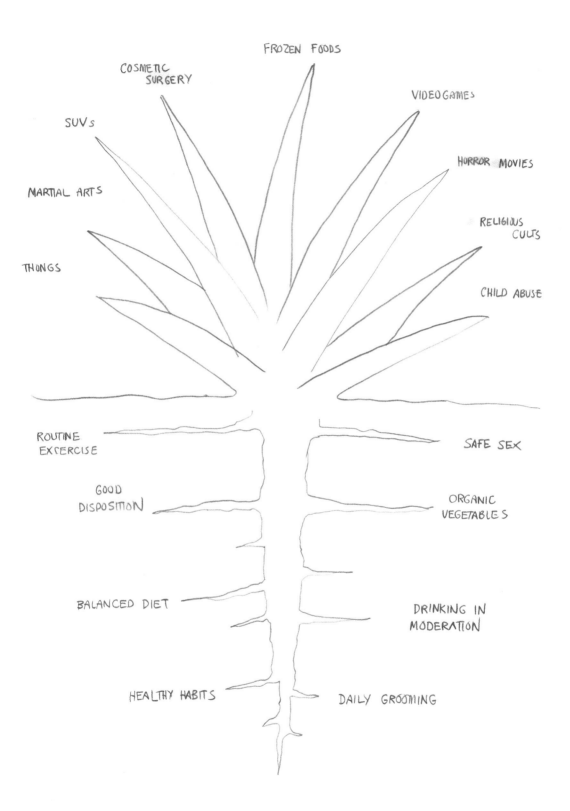

FROZEN FOODS

COSMETIC
SURGERY

VIDEOGAMES

SUVs

HORROR MOVIES

MARTIAL ARTS

RELIGIOUS
CULTS

THONGS

CHILD ABUSE

ROUTINE
EXERCISE

SAFE SEX

GOOD
DISPOSITION

ORGANIC
VEGETABLES

BALANCED DIET

DRINKING IN
MODERATION

HEALTHY HABITS

DAILY GROOMING

12. One World

13. We Are What We Eat ①

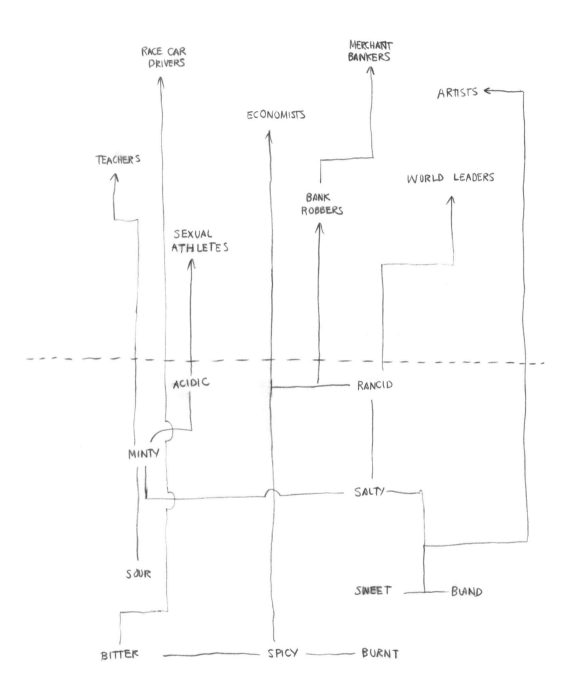

RACE CAR
DRIVERS

MERCHANT
BANKERS

ARTISTS

ECONOMISTS

TEACHERS

WORLD LEADERS

SEXUAL
ATHLETES

BANK
ROBBERS

ACIDIC

RANCID

MINTY

SALTY

SOUR

SWEET — BLAND

BITTER — SPICY — BURNT

14. Entropy

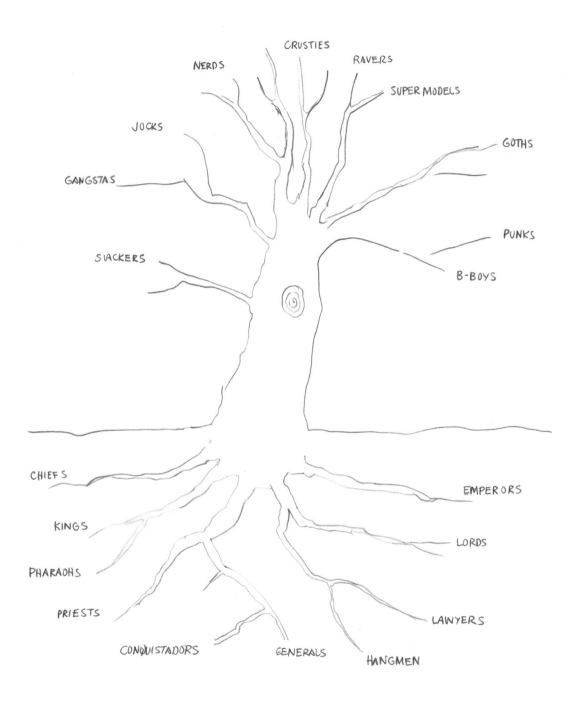

15. Alternate Universes

HERE

OURS

MINE

THIS

NOW

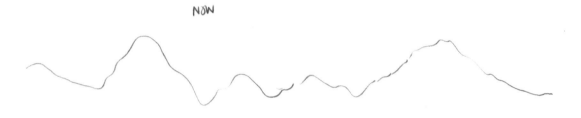

THAT

THEIRS

HERS

THERE

YOURS

HIS

THEN

16. Backwards History

THE DISTANT FUTURE →

SOON →

NOW

THEN ←

A LONG TIME AGO ←

COLONIZATION OF N. AMERICA

WW I

EIFFEL TOWER

OIL DISCOVERED

ATOMIC BOMB

WWII

MARILYN MONROE

DNA DISCOVERED

CONDOMS

ROCK & ROLL

THE PILL

STEVEN SPIELBERG

VIETNAM WAR

PERSONAL COMPUTERS

THE INTERNET

RWANDA

YUGOSLAVIA BREAKUP

AIDS

AFGHANISTAN

FAMINE IN CHINA

LIGHT STOPPED

FALL OF USA

DISCOVERY OF U-ONS

ARAFAT CROWNED

DNA SYNTHESIZED

CHEMICAL WARS DECLARED

HINDU TEMPLE OF PARIS COMPLETED

VINCENT DI GAMBAS

NORTH AMERICA DECLARED
UNINHABITABLE

SEX PERMITTED WITH ANYTHING

COLONIZATION OF MARS BEGUN

17. The Corporate Body ①

HOSTILE TAKEOVERS

DUE
DILIGENCE

CONFERENCES

DISCOVERY

ACQUISITIONS

CORPORATE
RETREATS

MERGERS

DANCING

DATING

CHATTING

FLIRTING

TEXTING

MEETING

TEASING

E-MAILING

DRINKING

LOOKING

18. Gustatory Rainbow ①

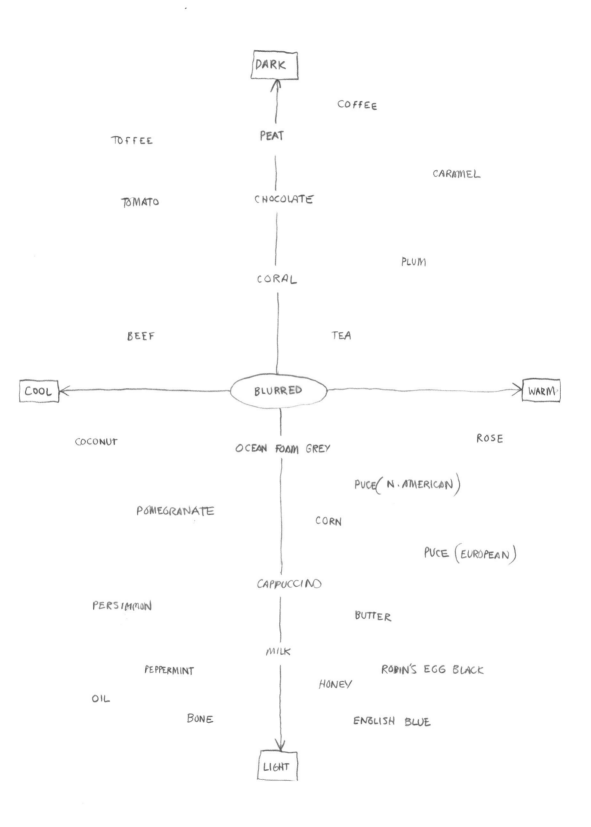

19. Morphological Similarities ⓘ

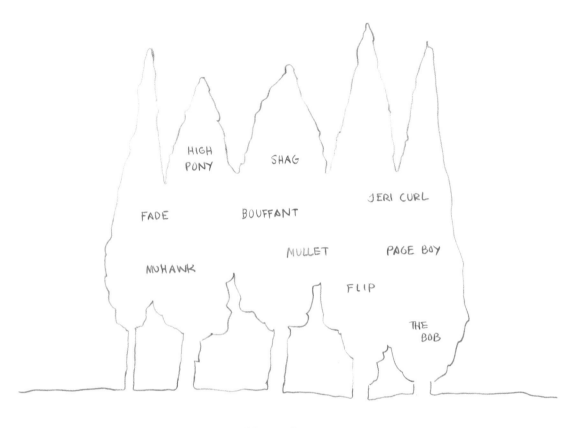

HIGH
PONY

SHAG

JERI CURL

FADE

BOUFFANT

MULLET

PAGE BOY

MOHAWK

FLIP

THE
BOB

PRETZELS

CHIPS

TOAST POINTS

CRACKERS

MIXED NUTS

DIPS

CRUDITÉS

POPCORN

20. Blake's Dilemma ⓘ

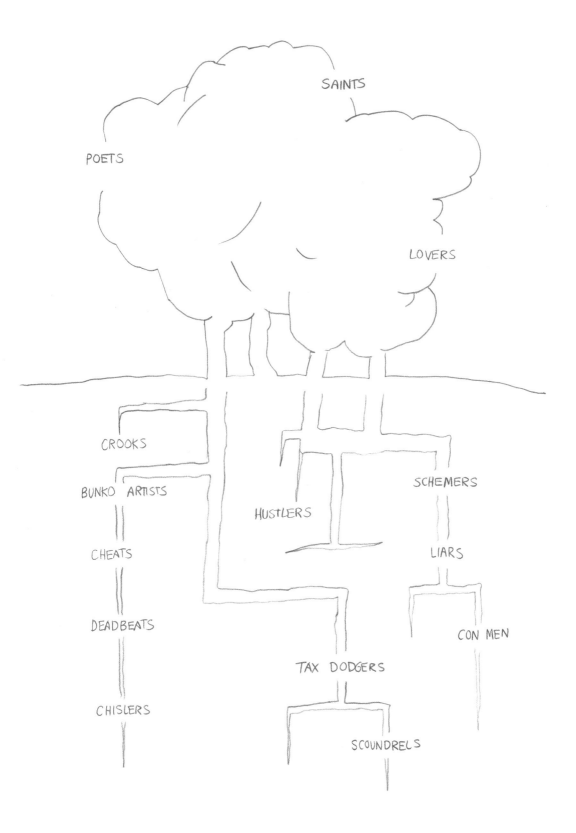

21. Economic Indicators ⓘ

RELATIVE COSTS

180 ─
140 ─
130 ─
120 ─
110 ─
100 ─
90 ─
80 ─
70 ─
60 ─
50 ─
40 ─
30 ─
20 ─
10 ─

LOSSES DUE TO CORPORATE FAILURE

LOSSES DUE TO TELEVISION

LOSSES DUE TO GUERILLA ACTIVITY IN LATIN AMERICA

LOSSES DUE TO HAIRBALLS & GREASE

LOSSES DUE TO LACK OF FUNDS

LOSSES DUE TO IMAGINARY ENEMIES

LOSSES DUE TO FAULTY PLAYSTATIONS

LOSSES DUE TO INCORRECTLY REPORTED RESULTS

22. Roots of War in Popular Song (Forest of No Return) ⓘ

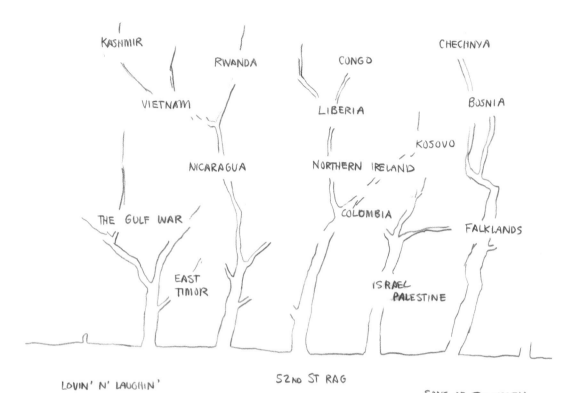

KASHMIR

RWANDA

CONGO

CHECHNYA

VIETNAM

LIBERIA

BOSNIA

KOSOVO

NICARAGUA

NORTHERN IRELAND

THE GULF WAR

COLOMBIA

FALKLANDS

EAST TIMOR

ISRAEL
PALESTINE

LOVIN' N' LAUGHIN'

52ND ST RAG

SONG OF THE NORTH

STRANGER IN SATIN

BEIGE FANTASY

BOOTLEG LOVE

BLUER THAN YOU

GOD BLESS THIS CHAIR

CHARLIE'S GIRL

BLESSED BETTY

IN BROADWAY'S SHADOW

WINSOME STRANGER

LET'S GET POSITIVE

INVISIBLE SOLITUDE

BUFFALO BON BONS

PATHETIC LOSER

LOSIN' TH' LADY

IF YOU KNEW ME

PHILADELPHIA PICNIC

IF WISHES WERE LEFTOVERS

TROPICAL TORPOR

23. The Roots of Consensual Sciences ⓘ

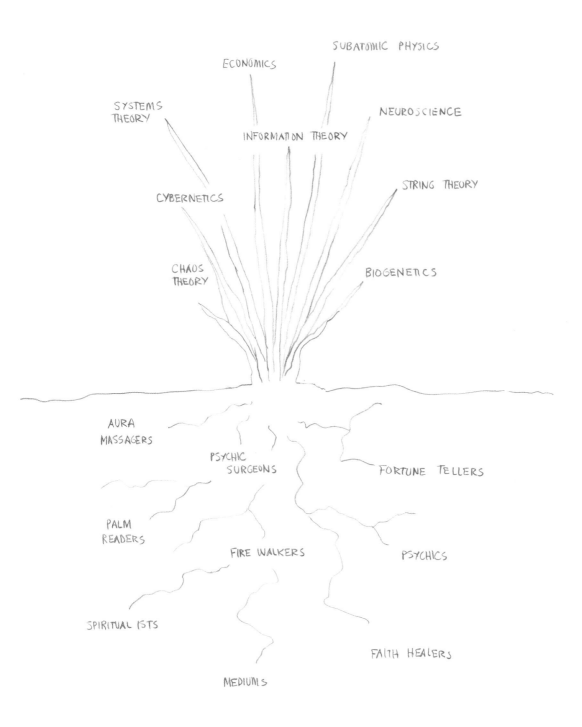

SUBATOMIC PHYSICS

ECONOMICS

SYSTEMS
THEORY

NEUROSCIENCE

INFORMATION THEORY

CYBERNETICS

STRING THEORY

CHAOS
THEORY

BIOGENETICS

AURA
MASSAGERS

PSYCHIC
SURGEONS

FORTUNE TELLERS

PALM
READERS

FIRE WALKERS

PSYCHICS

SPIRITUALISTS

FAITH HEALERS

MEDIUMS

24. Selective Memories ⓘ

PHOTOGRAPHS

PARTIALLY READ
BOOKS

LETTERS

MELODIC FRAGMENTS

GIFTS

SEXY MEMORIES

HAIRBALLS

STAINS

CRUMBS IN BED

STICKY STUFF

BLOODY SHEETS

SPIT

UNIDENTIFIED CRUD

USED TISSUES

VACANT STARES

25. Various Positions ⓘ

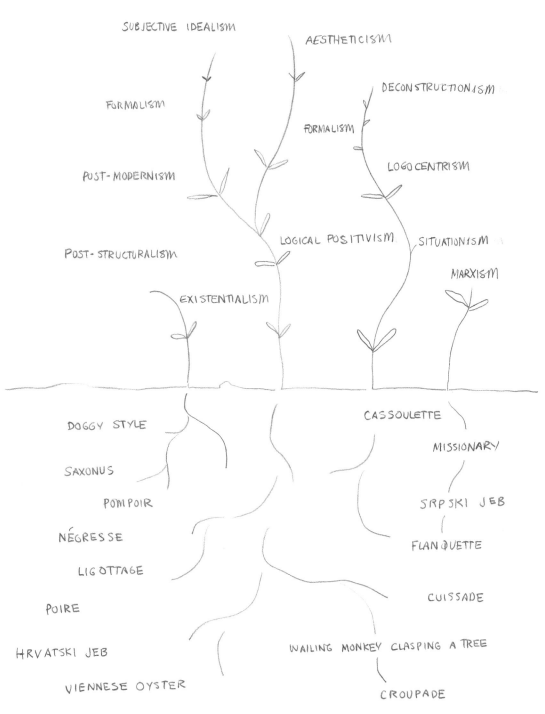

SUBJECTIVE IDEALISM

AESTHETICISM

DECONSTRUCTIONISM

FORMALISM

FORMALISM

LOGOCENTRISM

POST-MODERNISM

POST-STRUCTURALISM

LOGICAL POSITIVISM

SITUATIONISM

MARXISM

EXISTENTIALISM

DOGGY STYLE

CASSOULETTE

MISSIONARY

SAXONUS

POMPOIR

SRPSKI JEB

NÉGRESSE

FLANQUETTE

LIGOTTAGE

POIRE

CUISSADE

HRVATSKI JEB

WAILING MONKEY CLASPING A TREE

VIENNESE OYSTER

CROUPADE

WILD GEESE FLYING ON THEIR BACKS

26. Winnebago Trainspotters ⓘ

MULLAHS

RABBIS

PRIESTS

NUNS

SHAMANS

MONKS

GURUS

SADUHS

BIRD WATCHERS

RECORD COLLECTORS

LITERARY CRITICS

ASTRONOMERS

MODEL RAILROADERS

ECONOMISTS

FLY FISHERS

AUTOGRAPH COLLECTORS

CURATORS

FLOWER ARRANGERS

I.T. DESIGNERS

27. Physical Inspiration ⓘ

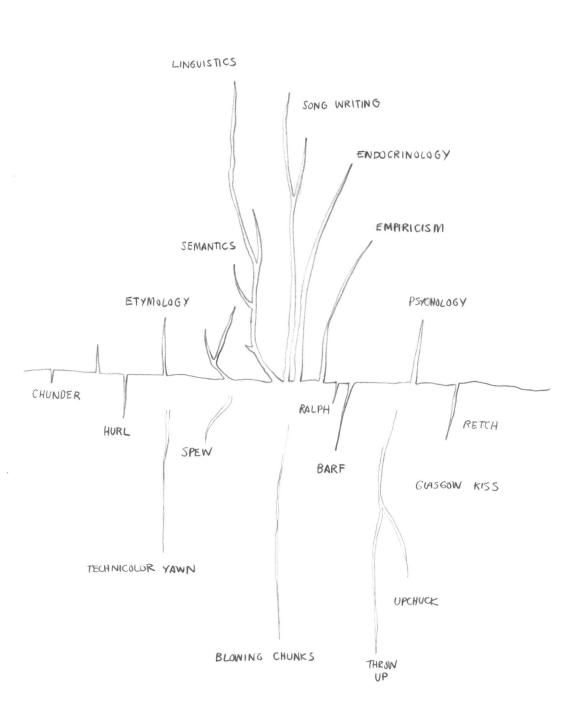

LINGUISTICS

SONG WRITING

ENDOCRINOLOGY

EMPIRICISM

SEMANTICS

ETYMOLOGY

PSYCHOLOGY

CHUNDER

RALPH

HURL

RETCH

SPEW

BARF

GLASGOW KISS

TECHNICOLOR YAWN

UPCHUCK

BLOWING CHUNKS

THROW
UP

28. Psychosexual Clouds ⓘ

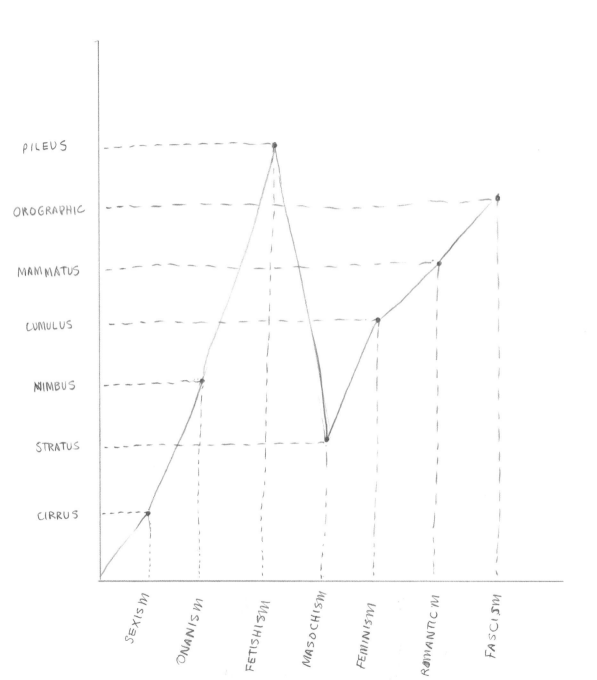

Y-axis (top to bottom): PILEUS, OROGRAPHIC, MAMMATUS, CUMULUS, NIMBUS, STRATUS, CIRRUS

X-axis: SEXISM, ONANISM, FETISHISM, MASOCHISM, FEMINISM, ROMANTICISM, FASCISM

29. Morally Repugnant

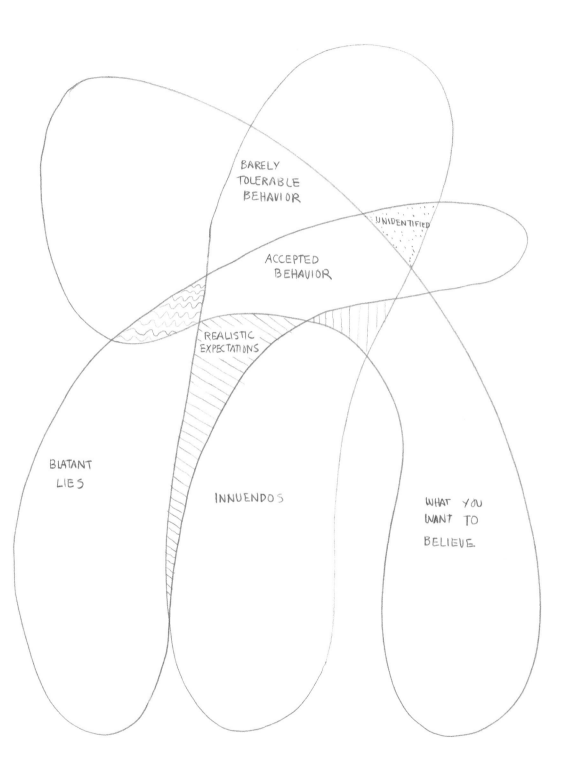

30. Becoming Immaterial ⓘ

INVOCATIONS

CHANTS

PROMISES

INCANTATIONS

SONGS

TEARS

WISHES

UNDERWEAR

PRAYERS

JEWELRY

PANTIES

SOCKS

NYLONS

CONDOMS

HAVING SEX

MAKING LOVE

GOIN' AT IT

GETTIN' SOME

SHAGGIN'

HUMPIN'

DOIN' IT

SCREWING

FUCKIN'

GETTIN' IT ON

HIDING THE SAUSAGE

BONIN'

31. Negative Space

HUGE CROWDS

ALL OF US

THE ASSEMBLED

EVERYONE

MASSIVE GATHERINGS

MULTITUDES

32. Space-Time Reflexivity ①

VAGUE CONCEPTS

THOUGHTS

ARCHETYPES

GODS & GODDESSES

CHAT ROOM AVATARS

POLITICIANS

CELEBRITIES

STATUES

SPACE

HISTORICAL FICTION

SUPERHEROES

MYTHICAL CREATURES

FAMILY MEMBERS

SHRUBS & BUSHES

PETS

WILD ANIMALS

TIME

BACTERIA

MOLDS

AIR

WATER

LAND

IDEAS

VAGUE CONCEPTS

33. History of Mark Making ⓘ

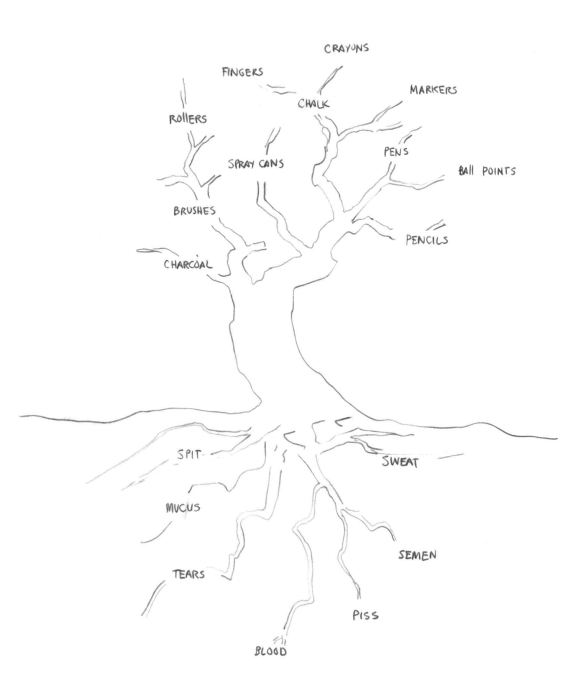

34. Roots of Philosophy ⓘ

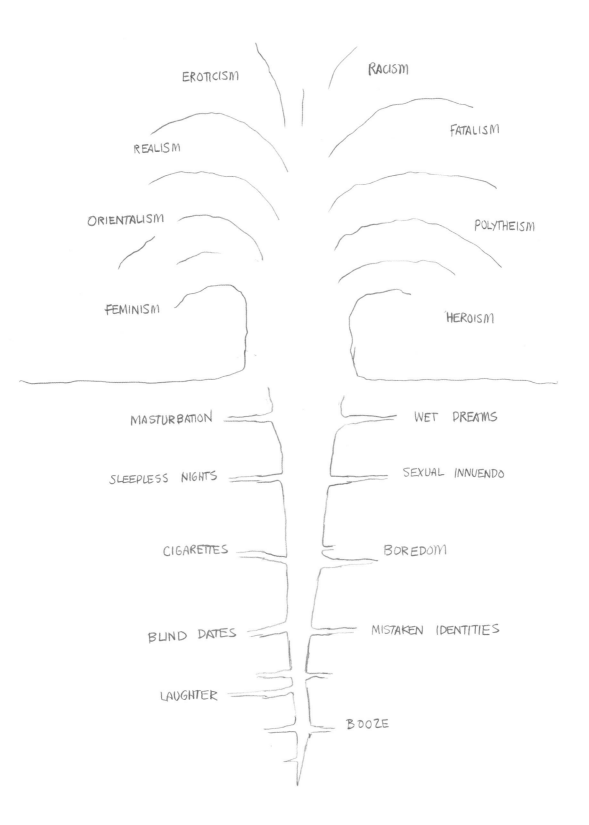

—

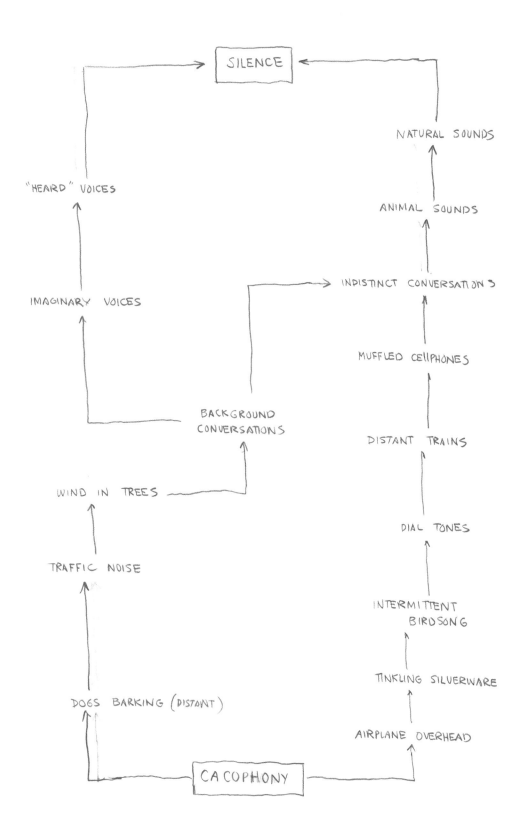

36. Granular Synthesis ①

PURE SCIENCE

TRUE LOVE

RELIGION

POETRY

PHILOSOPHY

HACKNEYED EXPRESSIONS

FAMOUS QUOTATIONS

COLLOQUIAL PHRASES

JARGON

QUOTES FROM SHAKESPEARE

COMMON EXPRESSIONS

MEANINGLESS SAYINGS

ADVERTISING JINGLES

POP SONG LYRICS

37. Acts of God / Acts of Man ⓘ

TIDAL WAVES

HURRICANES

FLOODS

VOLCANOES

MUDSLIDES

EARTHQUAKES

TORNADOES

DROUGHTS

BRUSHFIRES

MUD PACKS

COLONICS

FACIALS

ENEMAS

MASSAGES

PEDICURES

FOOT BATHS

MANICURES

38. Nocturnal Organizing Systems ⓘ

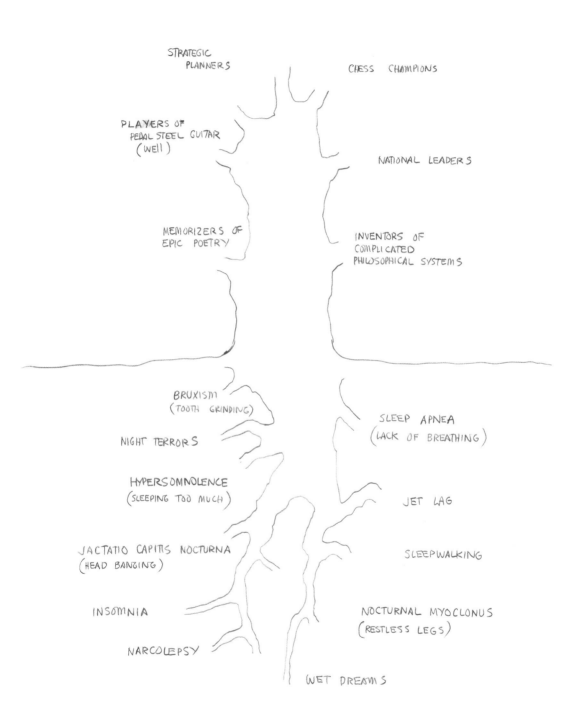

STRATEGIC PLANNERS

CHESS CHAMPIONS

PLAYERS OF PEDAL STEEL GUITAR (WELL)

NATIONAL LEADERS

MEMORIZERS OF EPIC POETRY

INVENTORS OF COMPLICATED PHILOSOPHICAL SYSTEMS

BRUXISM (TOOTH GRINDING)

SLEEP APNEA (LACK OF BREATHING)

NIGHT TERRORS

HYPERSOMNOLENCE (SLEEPING TOO MUCH)

JET LAG

JACTATIO CAPITIS NOCTURNA (HEAD BANGING)

SLEEPWALKING

INSOMNIA

NOCTURNAL MYOCLONUS (RESTLESS LEGS)

NARCOLEPSY

WET DREAMS

39. Imaginary Social Relationships

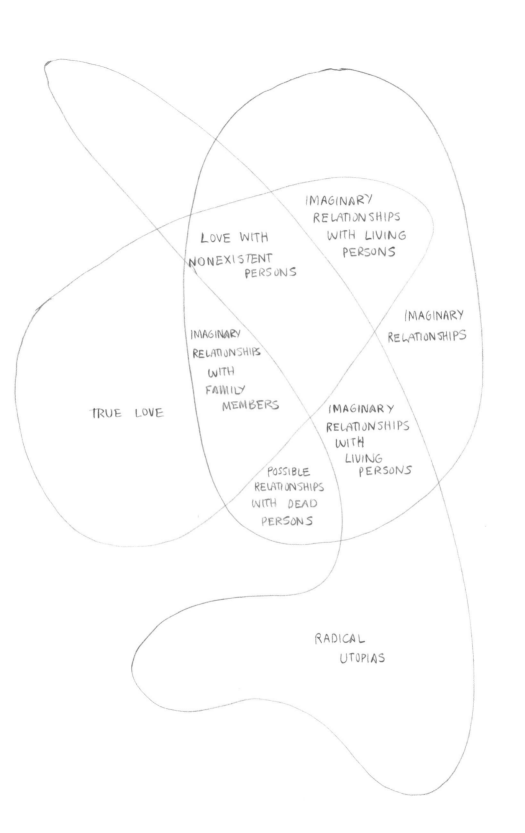

40. Household Mutations ⓘ

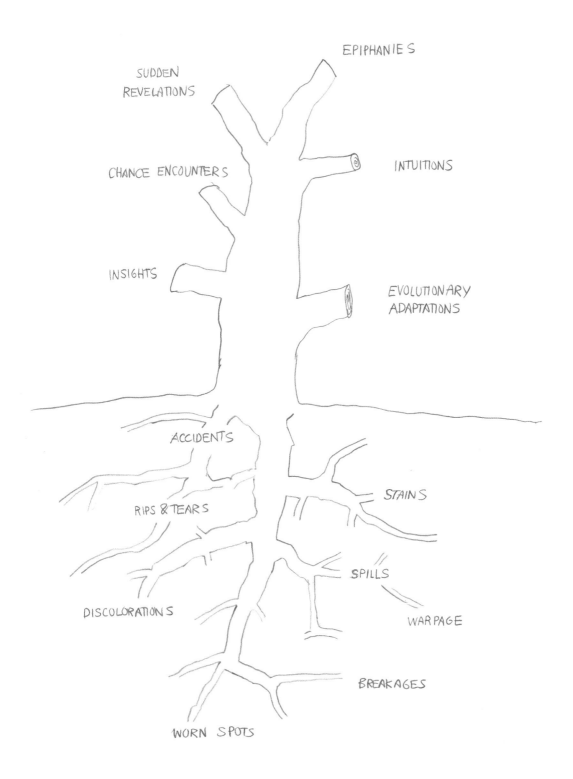

41. Auto-Epiglottal Systems

42. Delicious Disasters

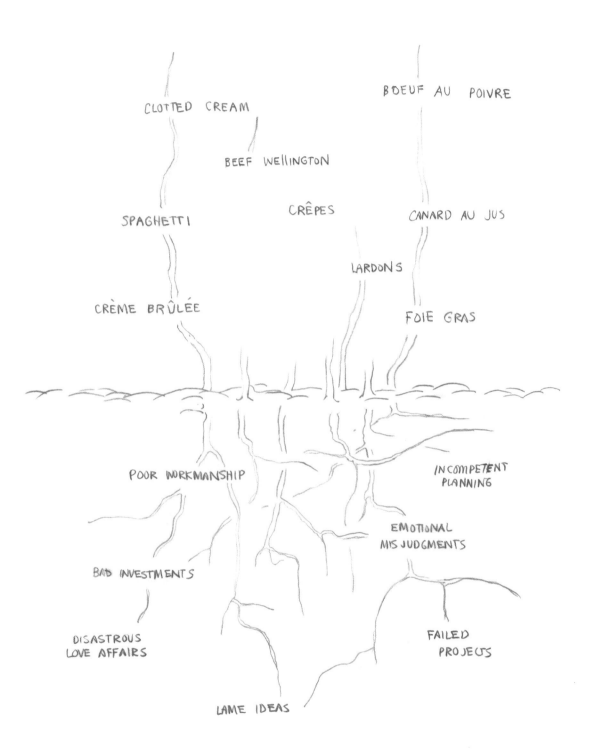

43. Movement to Gestural Transformation ⓘ

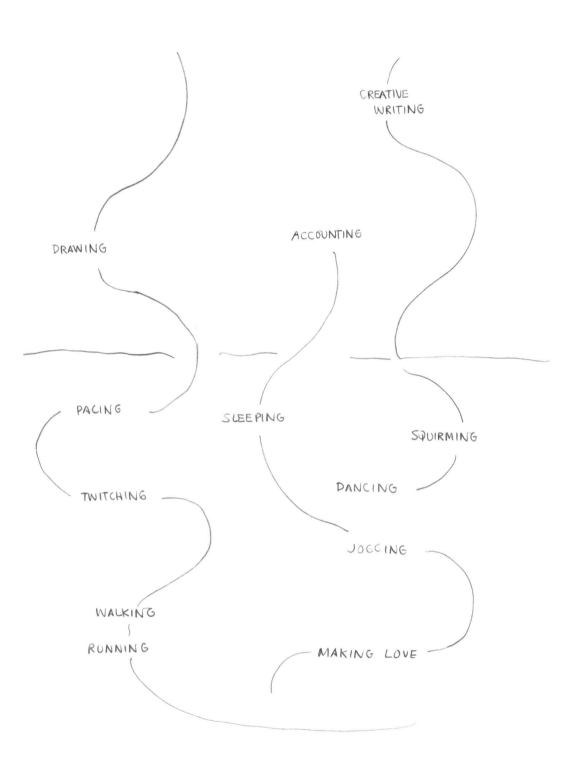

44. Time Management ⓘ

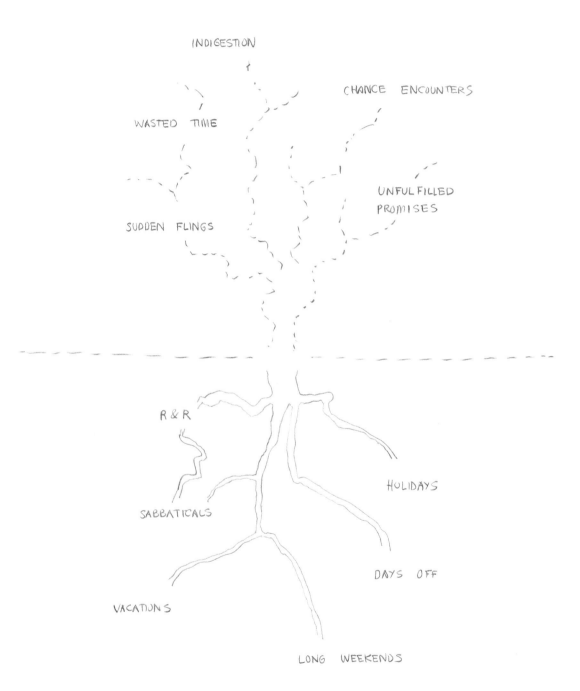

45. When Good Lovin' Goes Bad ⓘ

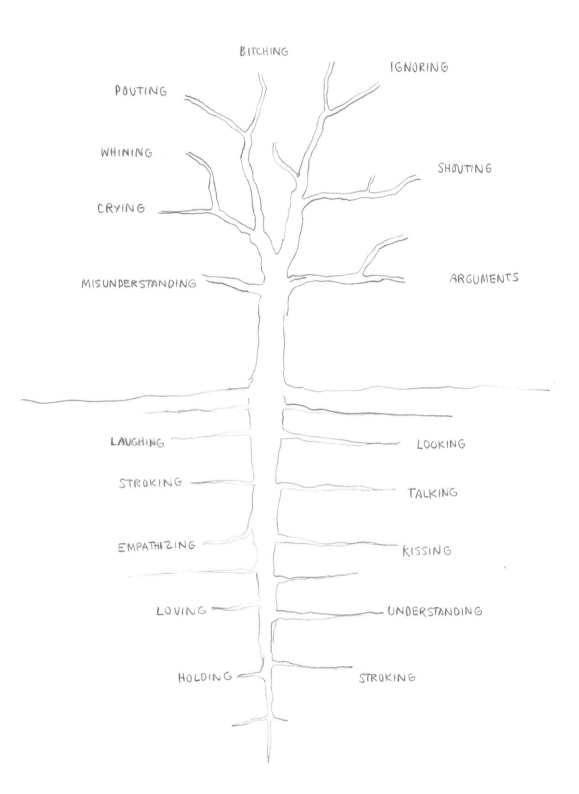

46. Luxurious Transformations ⓘ

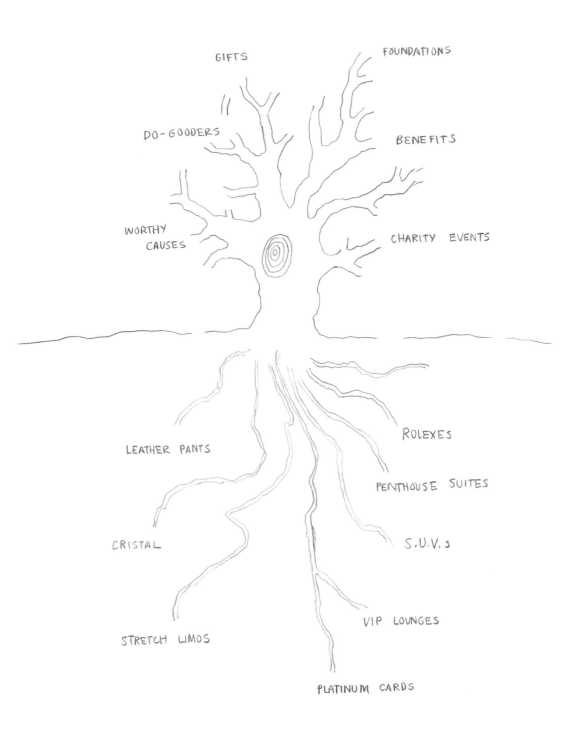

47. Vertical Rhizome ⓘ

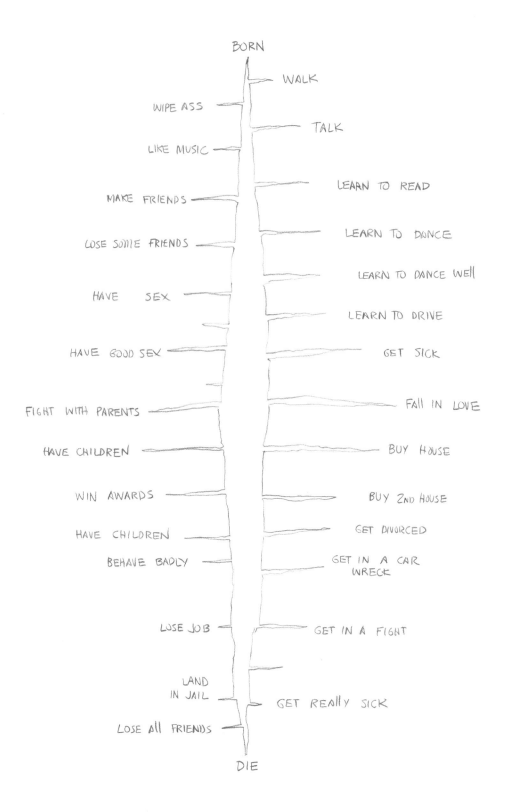

48. Flying Blind ⓘ

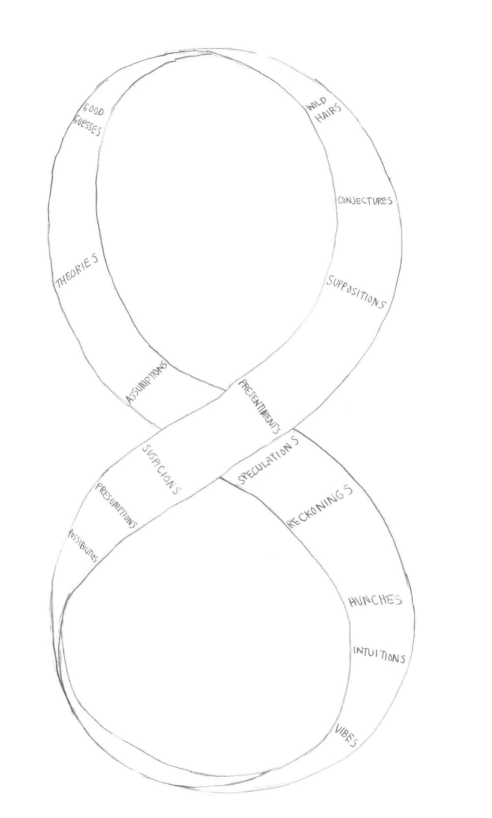

49. Material / Immaterial Metamorphosis ⓘ

CREATIVITY BLISS

 GENIUS EXUBERANCE

 JOY

 HAPPINESS

 PEACE

 LOVE

CHILDHOOD FEARS

 INFECTIOUS DISEASES

 HANGNAILS

 HEARTBREAK

MOSQUITO BITES

 REVENGE FANTASIES

 COLD SORES

 SEXUAL ANXIETY

 SOILED UNDERWEAR

 POOR GRADES

50. The Performing Arts ⓘ

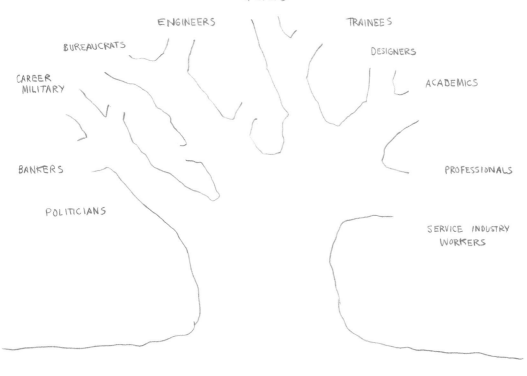

LAWYERS

ENGINEERS

BUREAUCRATS

TRAINEES

DESIGNERS

CAREER
MILITARY

ACADEMICS

BANKERS

PROFESSIONALS

POLITICIANS

SERVICE INDUSTRY
WORKERS

REVUE

MUSICALS

OFF-BROADWAY

ONE-MAN SHOW

FRINGE

DANCE THEATER

REVIVAL

OFF-OFF-BROADWAY

51. Antipodes

DESERTIONS

DERISIONS DENIGRATIONS

DENIALS DECEPTIONS

DECEITS DEMANDS

DOUBTS DEMURRALS

SOFT TOUCHES

CONSIDERATE
THOUGHTS

LOVING EMBRACES AFFECTIONATE LOOKS

TENDER KISSES CUDDLES

ROMANTIC
GESTURES

52. Gangs

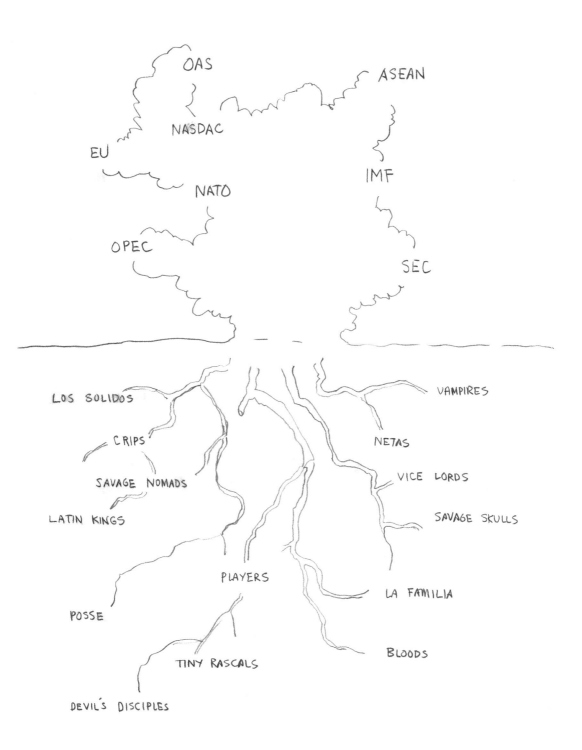

53. In Vino Veritas ⓘ

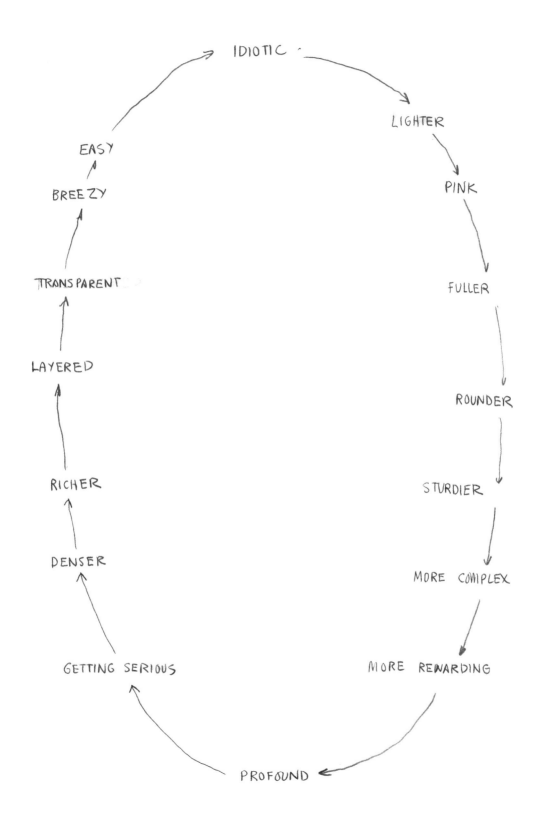

54. Corpomundonervioso ⓘ

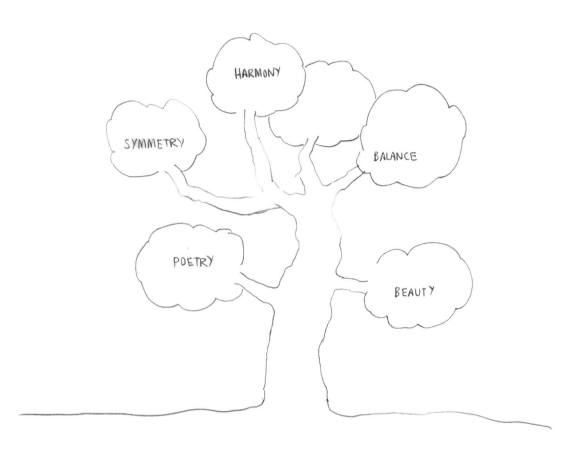

FINGERNAIL BITING

FARTING

HAIR TWIRLING

NOSE PICKING

CUTICLE PEELING

BALL SCRATCHING

EAR POKING

BUTT ITCHING

55. Constellations of Desire

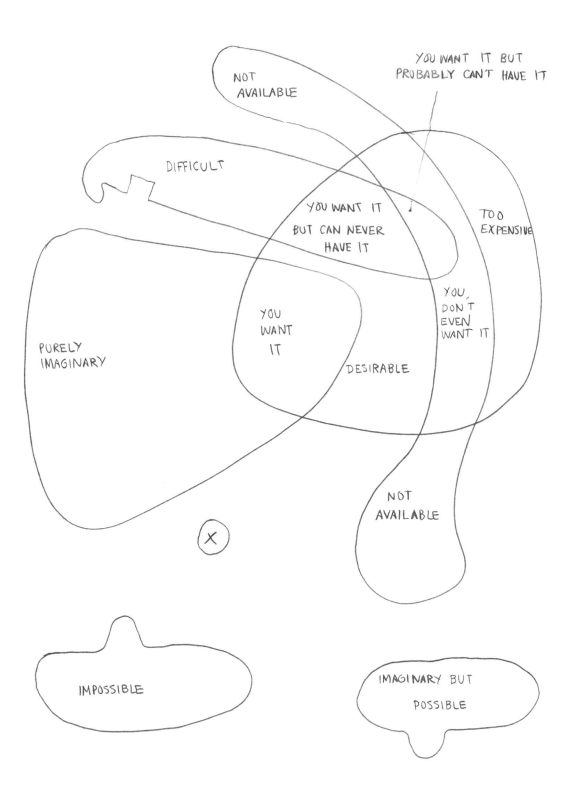

56. Group Therapy

PHYSICAL
HUMOR

ONE - LINERS

PUNS

TOILET JOKES

DYSFUNCTIONAL FAMILIES

DIVORCE

ALIENATION

CHILD ABUSE

BIPOLAR DISORDER

SEXUAL ANXIETIES

GAGS

DOUBLE
ENTENDRES

WISECRACKS

SLAPSTICK

57. New Corporate Galaxies ⓘ

OMEGA

URSA MINOR

CYGNUS

VULPECULA

CETUS A (M 77)

ALPHA CENTAURI

PRAESEPE
(BEEHIVE CLUSTER)

CANOPUS

TRIANGULUM (M 33)

PROXIMA CENTAURI

CORONA BOREALIS

HYADES

ANDROMEDA

CASSIOPEIA

ZWICKY #2

GLAXO

XEROX

LUCENT

VERIZON

VEOLIA

ALTRIA

EXPEDIA

VERITAS

OPODO

58. The Garden of Eden ⓘ

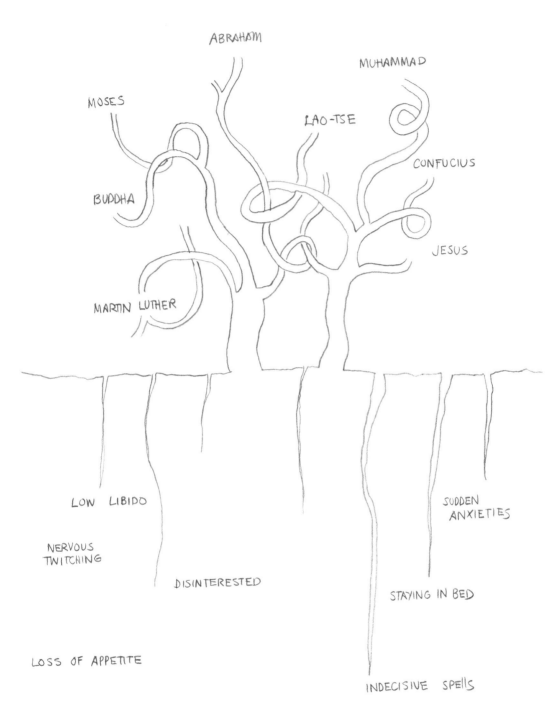

ABRAHAM

MUHAMMAD

MOSES

LAO-TSE

CONFUCIUS

BUDDHA

JESUS

MARTIN LUTHER

LOW LIBIDO

SUDDEN
ANXIETIES

NERVOUS
TWITCHING

DISINTERESTED

STAYING IN BED

LOSS OF APPETITE

INDECISIVE SPELLS

LACK OF AMBITION

59. Origin of the Species ⓘ

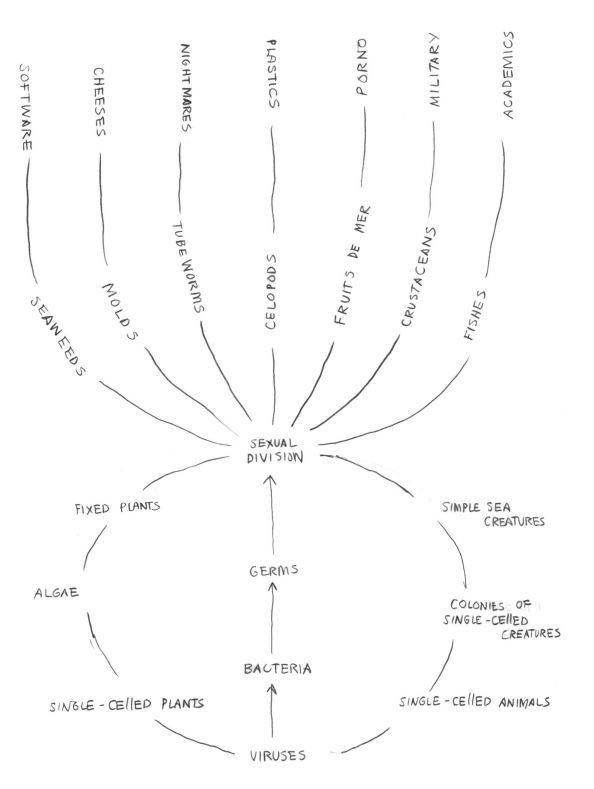

SOFTWARE

CHEESES

NIGHTMARES

PLASTICS

PORNO

MILITARY

ACADEMICS

TUBEWORMS

MOLDS

CELOPODS

FRUITS DE MER

CRUSTACEANS

FISHES

SEAWEEDS

SEXUAL
DIVISION

FIXED PLANTS

SIMPLE SEA
CREATURES

GERMS

ALGAE

COLONIES OF
SINGLE-CELLED
CREATURES

BACTERIA

SINGLE-CELLED PLANTS

SINGLE-CELLED ANIMALS

VIRUSES

60. Flexibility—Liability ⓘ

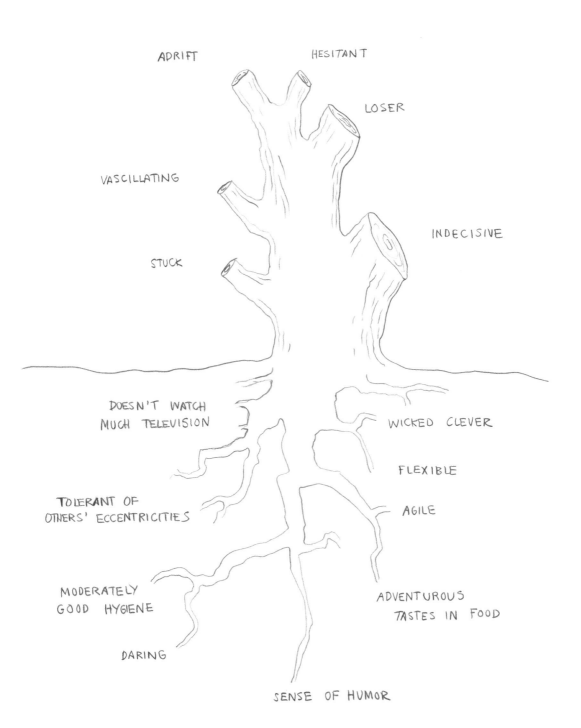

61. The Subtle & The Physical Body (Male POV) ⓘ

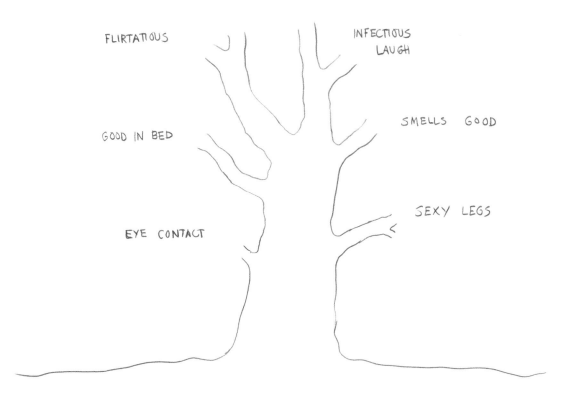

FLIRTATIOUS

INFECTIOUS LAUGH

SMELLS GOOD

GOOD IN BED

SEXY LEGS

EYE CONTACT

TUNNEL VISION

LOW EMPATHY

FORGETFULNESS

CONSPIRATORIAL LEANINGS

PARANOID FEARS

POOR ORGANIZATIONAL SKILLS

SHORT TEMPER

62. The Foundations of Pure Thought ①

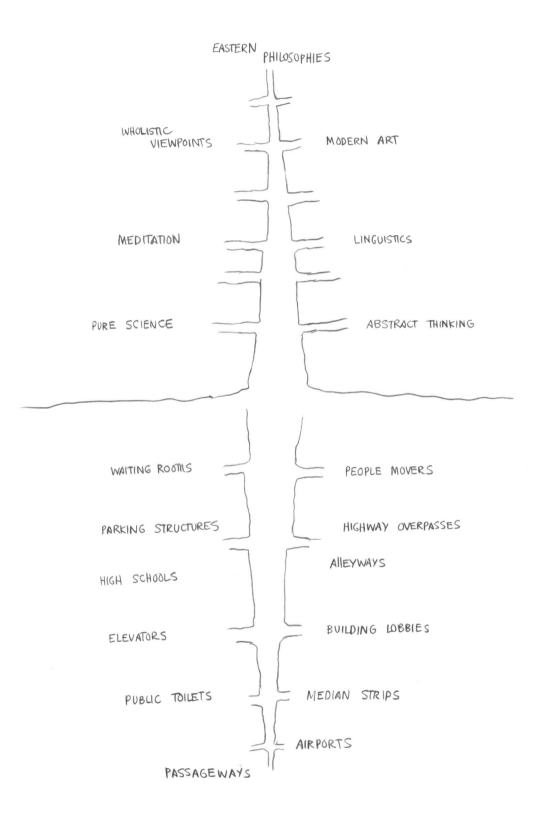

EASTERN PHILOSOPHIES

WHOLISTIC VIEWPOINTS

MODERN ART

MEDITATION

LINGUISTICS

PURE SCIENCE

ABSTRACT THINKING

WAITING ROOMS

PEOPLE MOVERS

PARKING STRUCTURES

HIGHWAY OVERPASSES

HIGH SCHOOLS

Alleyways

ELEVATORS

BUILDING LOBBIES

PUBLIC TOILETS

MEDIAN STRIPS

AIRPORTS

PASSAGEWAYS

63. The Evolution of Category ①

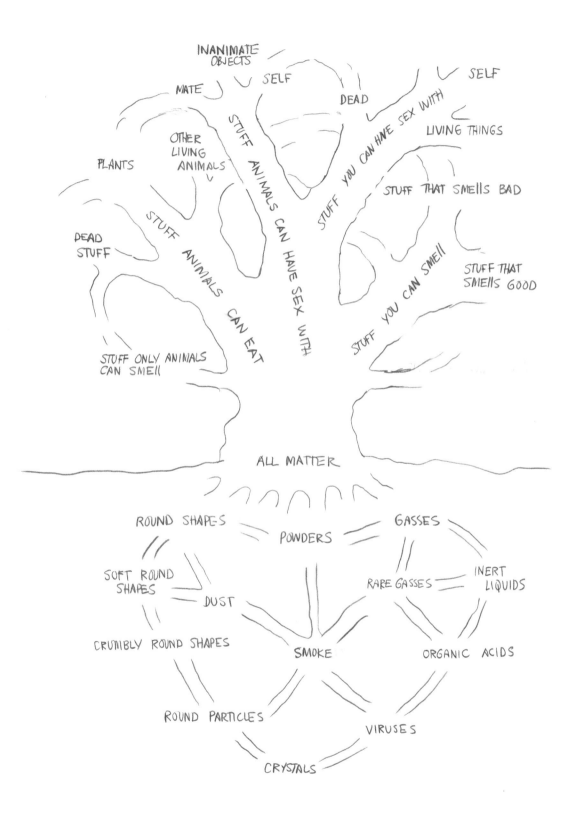

64. Möbius Kiss ⓘ

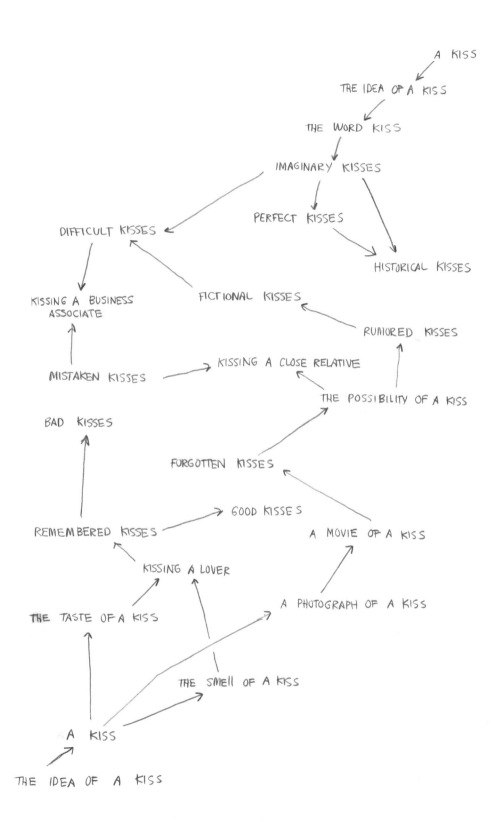

65. Theater of Relationships ①

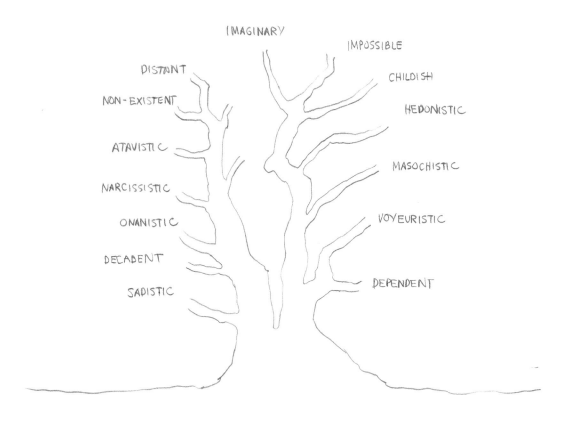

IMAGINARY

IMPOSSIBLE

DISTANT

CHILDISH

NON-EXISTENT

HEDONISTIC

ATAVISTIC

MASOCHISTIC

NARCISSISTIC

VOYEURISTIC

ONANISTIC

DEPENDENT

DECADENT

SADISTIC

DRAWING ROOM

TRAGEDY

FARCE

COMEDY

MUSICAL

WHODUNIT

SPOOF

REVUE

SATIRE

SKETCH

66. Hutcheson's Moral Senses ⓘ

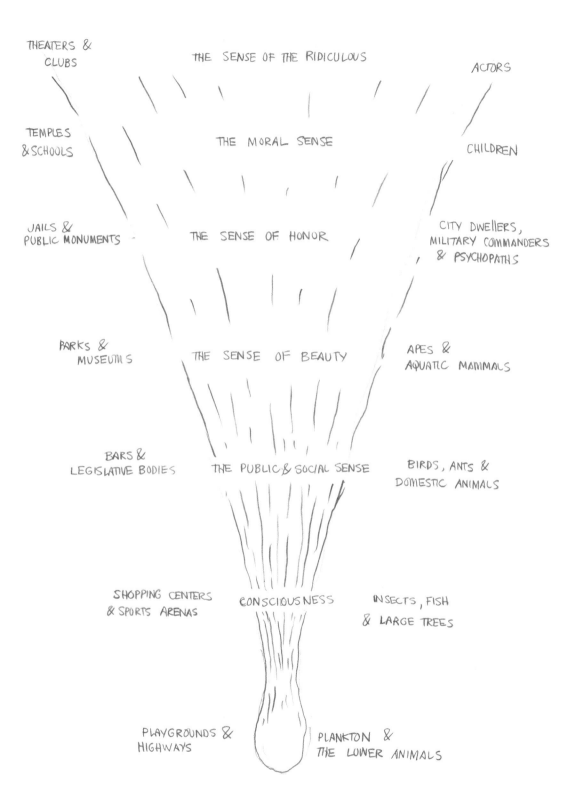

THEATERS & CLUBS

THE SENSE OF THE RIDICULOUS

ACTORS

TEMPLES & SCHOOLS

THE MORAL SENSE

CHILDREN

JAILS & PUBLIC MONUMENTS

THE SENSE OF HONOR

CITY DWELLERS, MILITARY COMMANDERS & PSYCHOPATHS

PARKS & MUSEUMS

THE SENSE OF BEAUTY

APES & AQUATIC MAMMALS

BARS & LEGISLATIVE BODIES

THE PUBLIC & SOCIAL SENSE

BIRDS, ANTS & DOMESTIC ANIMALS

SHOPPING CENTERS & SPORTS ARENAS

CONSCIOUSNESS

INSECTS, FISH & LARGE TREES

PLAYGROUNDS & HIGHWAYS

PLANKTON & THE LOWER ANIMALS

67. Dark Roots ⓘ

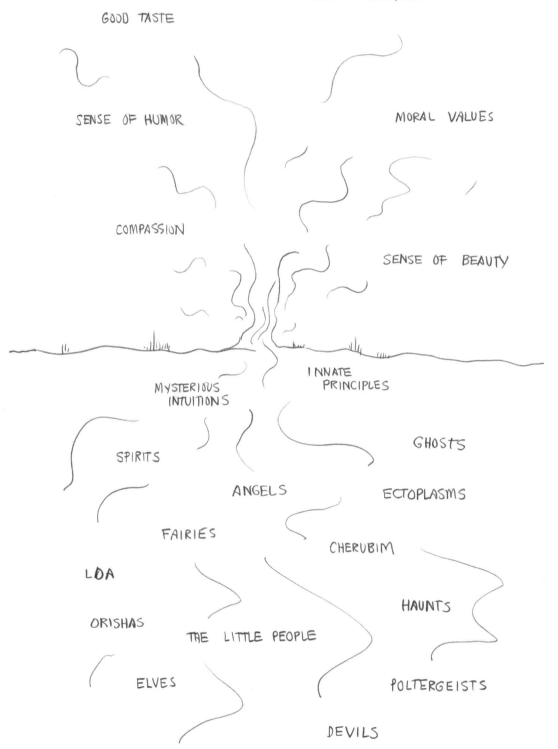

68. Nambikwara Verbal Suffix Categories ⓘ

THINGS PERTAINING
TO THE SEX ACT

THINGS NOT OF INTEREST
TO ANTHROPOLOGISTS

THINGS ANTHROPOLOGISTS
WILL PAY FOR

THINGS ANTHROPOLOGISTS
CANNOT SEE

THINGS BELONGING
TO ANTHROPOLOGISTS

THINGS THAT FRIGHTEN
ANTHROPOLOGISTS

THINGS CLOSE TO
ANTHROPOLOGISTS

THINGS THAT HANG
& QUIVER

HUMAN HAIR
(ALSO ANIMAL HAIR
& FEATHERS)

TREE BARKS, SKINS
& COVERINGS

POINTED OBJECTS
(OR ORIFICES)

FRUIT, SEEDS &
ROUNDED OBJECTS

ELONGATED OBJECTS
(RIGID OR PLIABLE)

SWOLLEN SHAPES
(OR FULL OF LIQUID)

69. The Evolution of Eating Utensils

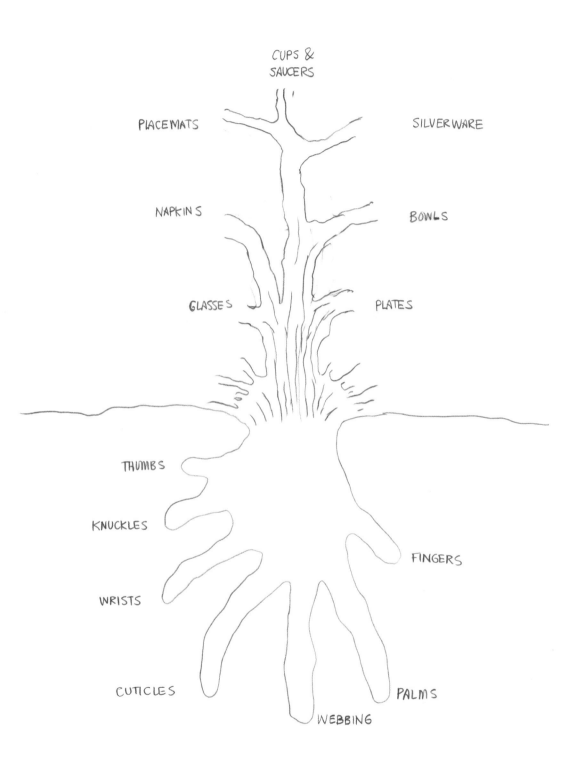

70. Ideological Struggle ①

THE OLSEN TWINS

WALT DISNEY

CHRISTMAS CAROLS

HALLMARK CARDS

HAPPY MEALS

SATURDAY MORNING TV

SOFT ROCK

71. Military Technology ①

PENCIL SHARPENERS SCISSORS

PEPPER MILLS PAPER SHREDDERS

STAPLERS HOLE PUNCHERS

BOTTLE OPENERS CARNIVAL RIDES

ONAGER

PETRARIA

MANGONELLA

CATAPULTA OXYBELES

BALLISTA
(PALINTONE) VULPUS

TESTUDO

SCORPIO CHEIROBALLISTA

EUTHYTONE TREBUCHET

72. Prefixes & Preludes ⓘ

HUGS

KISSES GIFTS

WINKS GESTURES

SMILES POSTURES

——————————— ———————————

DIS-
 UN-
PRE-
 NON-

ANTI-
 RE-

 BI-

73. Systems Thinking

TRUE.com

ANYTHINGDOING.COM

MYSPACE.COM

MEETING PEOPLE.COM

MATCH.COM

FRIENDSTER.COM

SINGLEME.COM

FRIENDFINDER.COM

NETRELATE.COM

INTERFACE DETAILING

SUPERVISORY HANDLING

FACILITATION MANAGEMENT

MANAGEMENT SKILLS

NEGOTIATION EXPERIENCE

GOOD PERFORMANCE HISTORY

PROMPTNESS

COMMUNICATION SENSITIVITY

RELATIONSHIP PROCESSING

74. Heaven's Cash Register ⓘ

TIME'S DUST

BLISSFUL ABEYANCE

RIGHTEOUS POLYPHONY

ORACLE TEASING

VULGAR REFLEXES

THE CLOUD OF UNKNOWING

FENESTRATION

SHANTYTOWN SLICK

GHETTO FABULOUS

REDNECK RICHE

FAVELA CHIC

ABORIGINE DEBUTANTE

75. Expressions of Aggressive Behavior ⓘ

MICROWAVE CUISINE SHOULDER PADS

FUSION FOODS MINIMAL DESIGN

TASTEFUL DECOR GOOD WORKS

CELL YELL GUITAR SOLOS

DOMINANCE
ASSERTION
 DEFENSE OF
 TERRITORY

HUNTING BEHAVIOR SEXUAL AGGRESSION

 DEFENSIVE DISPLAY
WEANING AGAINST PREDATORS

MORALISTIC SOCIAL RE·ENFORCEMENT

76. Möbius Structure of Relationships

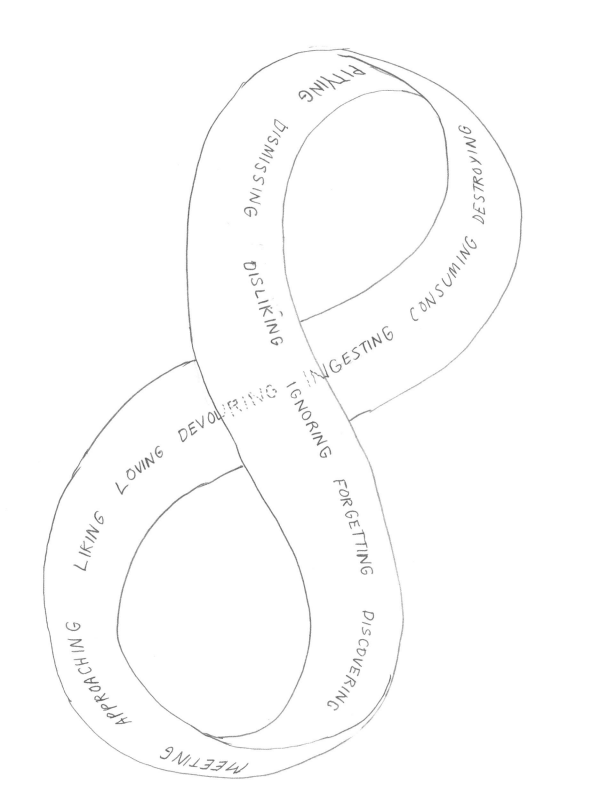

77. Corporate to Personal Homeomorphism ①

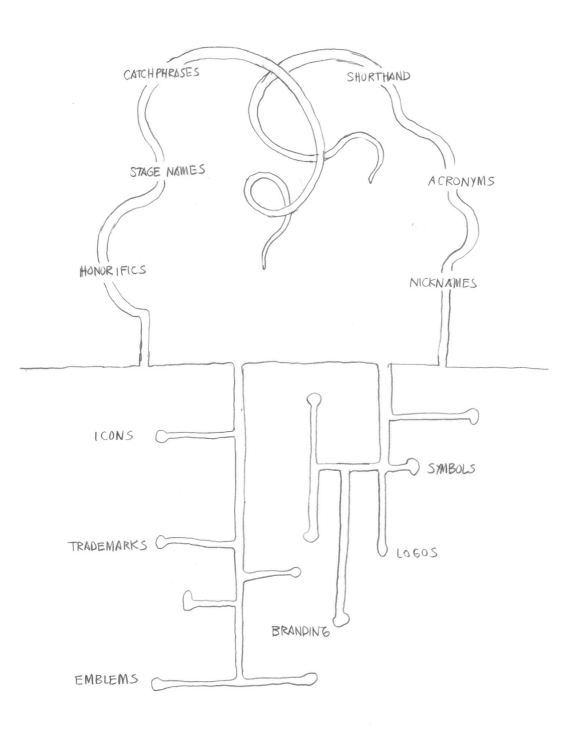

CATCHPHRASES

SHORTHAND

STAGE NAMES

ACRONYMS

HONORIFICS

NICKNAMES

ICONS

SYMBOLS

TRADEMARKS

LOGOS

BRANDING

EMBLEMS

78. Nostalgic Roots of Animal Behavior ⓘ

RUBBING

SCRATCHING SUCKING

BITING LICKING

———————————— ————————————

COMFORT FOOD

CLASSIC ROCK

SITCOMS

BLUE JEANS

GAS STATION

CANDY BARS

79. State Formalization of Obfuscation ⓘ

RESOLUTIONS
LAWS
STATUTES
AMENDMENTS
CONSTITUTIONS
CONCORD
DECLARATION
ATTACHMENTS
AGREEMENTS
DEAL MEMOS
CONTRACTS

CHANGING THE SUBJECT

DOING NOTHING

WILFULLY MISUNDERSTANDING

AVOIDING THE SUBJECT

ANSWERING WITH A QUESTION

CONFUSING THE ISSUE

80. Club Makes Culture

POETRY

ROACHES

JUNKIE BOYFRIENDS

BATH IN KITCHEN

HAIR STRIPPING

SLIDES WITH MUSIC

GRAFFITI ON CANVAS

POMADE

LEATHER JACKETS

WIGS

MOHAWKS

TIGHT PANTS

AIDS

BLACK

SINÉ

MERCURY LOUNGE

BROWNIE'S

CBGB

CONTINENTAL

THE WORLD

CLUB 57

DON HILL'S

THE 5 SPOT

PYRAMID

CONEY ISLAND HIGH

CHEETAH

ARLENE'S

TONIC

81. You'll Get Used to It ①

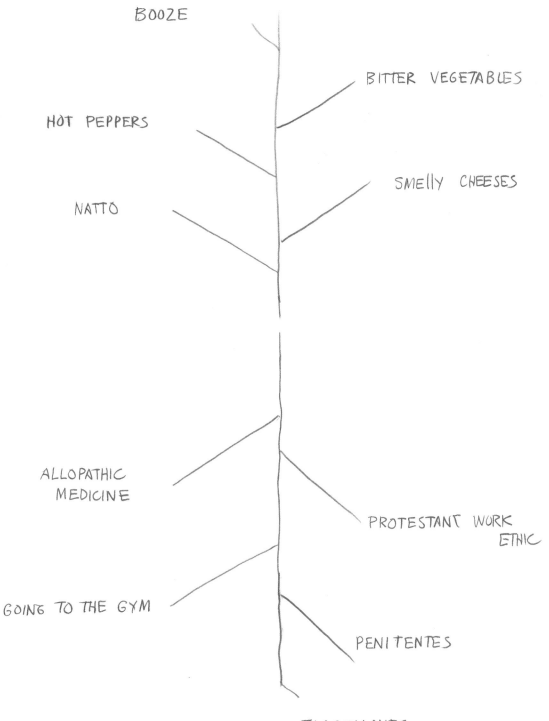

BOOZE

BITTER VEGETABLES

HOT PEPPERS

SMELLY CHEESES

NATTO

ALLOPATHIC
MEDICINE

PROTESTANT WORK
ETHIC

GOING TO THE GYM

PENITENTES

FLAGELLANTS

82. The Tree of Life

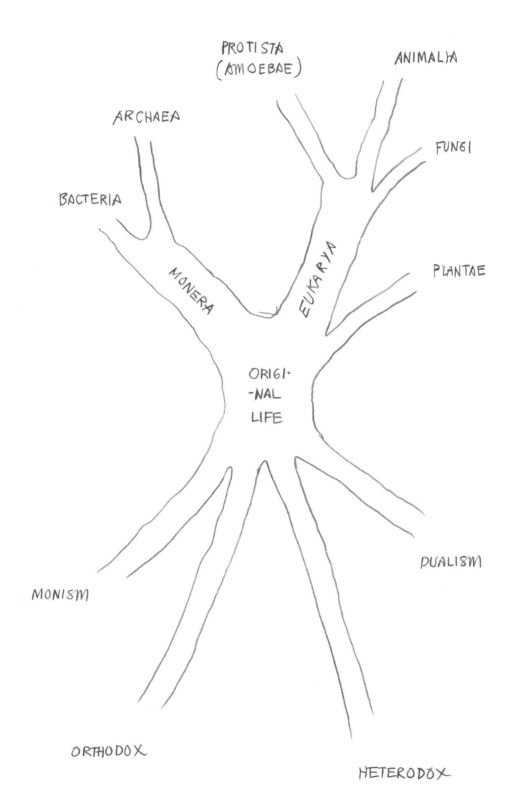

83. Synaesthesia ⓘ

ELECTRO CLASH

LOUNGE CORE

GOTH TRANCE

TRANCE

UK HOUSE

NEW AGE

GLAM

FREE JAZZ HIP HOP

LITE FM SLOW CORE

↑ ↓

UNEVEN

KNOBBY

JAGGED FUZZY

SMOOTH UNBLEMISHED ROUGH

BUMPY SMOOTH

STICKY SILKY

GRAINY

SPARKLY

84. Machine for Living

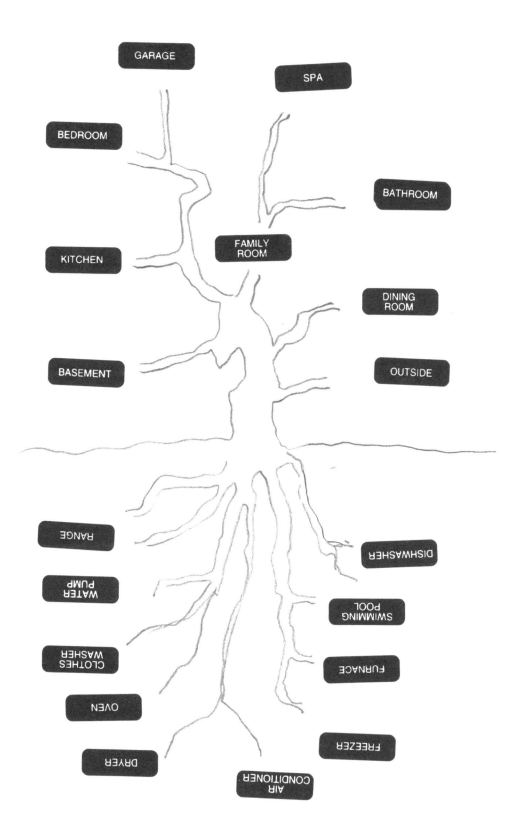

85. Wet Philosophy ⓘ

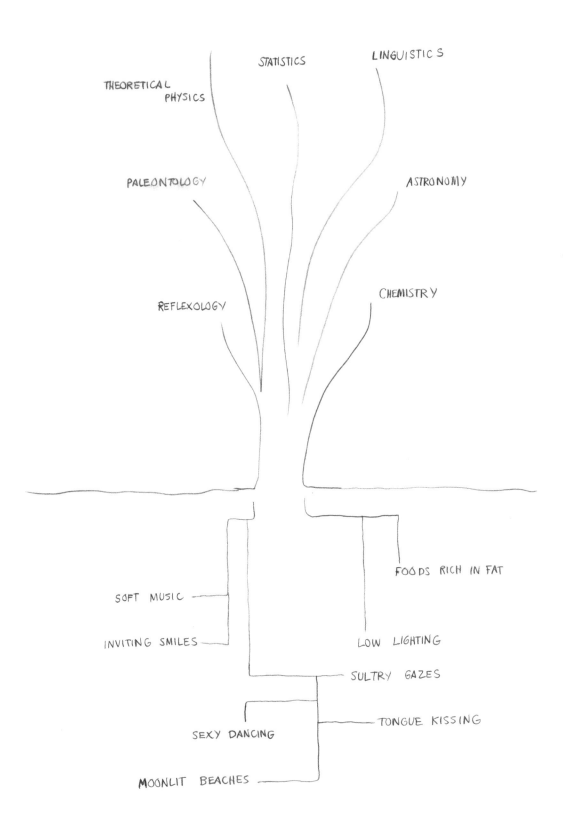

86. Tower of Aphorisms

THERE IS NO SUCH THING AS A FREE LUNCH

↑

ANYTHING IS BETTER THAN NOTHING

↑ ↑

BIGGER IS NOT ALWAYS BETTER

↑ ↑ ↑

EVERYTHING IS CONNECTED TO EVERYTHING ELSE

↑ ↑ ↑

NOTHING COMES FROM NOTHING

↑ ↑ ↑

EVERYTHING'S GOT TO GO SOMEWHERE

↑ ↑ ↑ ↑ ↑

87. Roots of the Contemporary Environment

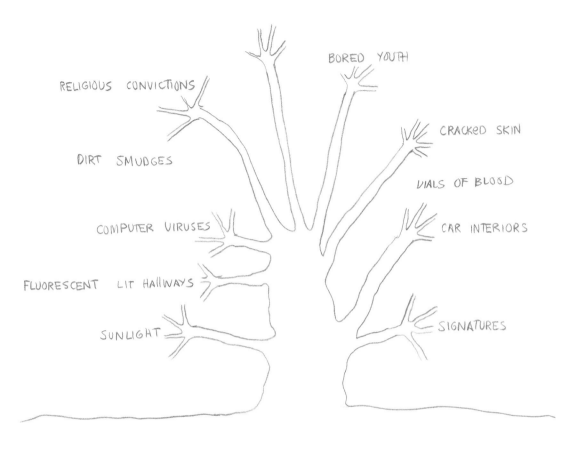

RELIGIOUS CONVICTIONS

BORED YOUTH

DIRT SMUDGES

CRACKED SKIN

VIALS OF BLOOD

COMPUTER VIRUSES

CAR INTERIORS

FLUORESCENT LIT HALLWAYS

SUNLIGHT

SIGNATURES

POP SONGS

CABLE TELEVISION

ROAD MAPS

OPERATING SOFTWARE

INSTRUCTION MANUALS

VITAMIN SUPPLEMENTS

THE INTERNET

88. Being There

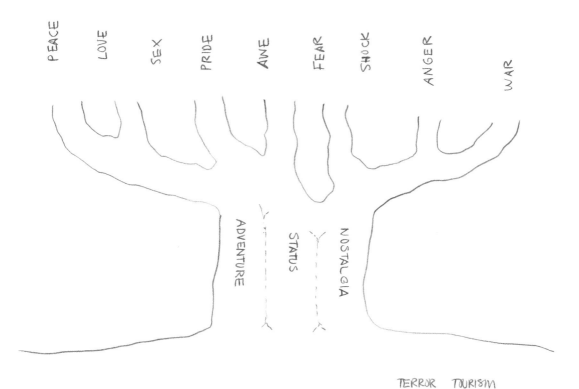

PEACE LOVE SEX PRIDE AWE FEAR SHOCK ANGER WAR

ADVENTURE STATUS NOSTALGIA

TERROR TOURISM

DISASTER TOURISM

RELIGIOUS TOURISM

GENEALOGICAL TOURISM

MEDICAL TOURISM

CULTURAL TOURISM

SEX TOURISM

DEATH TOURISM

ECOTOURISM

LITERARY TOURISM

SUICIDE TOURISM

89. Romantic Destiny

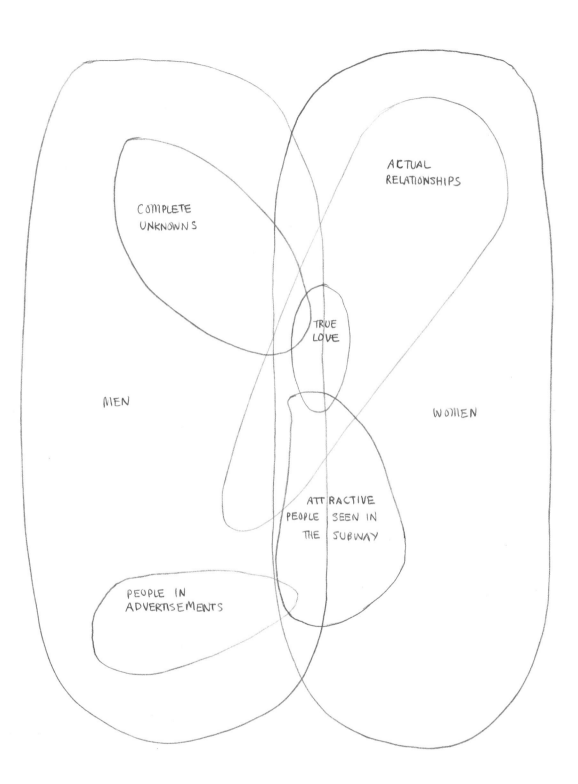

90. Facial Types (Wet to Dry)

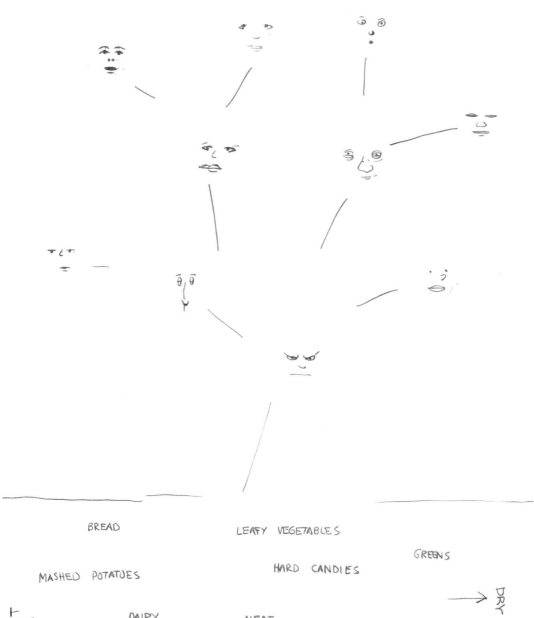

BREAD

LEAFY VEGETABLES

GREENS

MASHED POTATOES

HARD CANDIES

DRY

WET

DAIRY

MEAT

FRUITS

STEWS

POULTRY

CRACKERS

FISH

JAMS

NOODLES (UNCOOKED)

91. Social Transformation

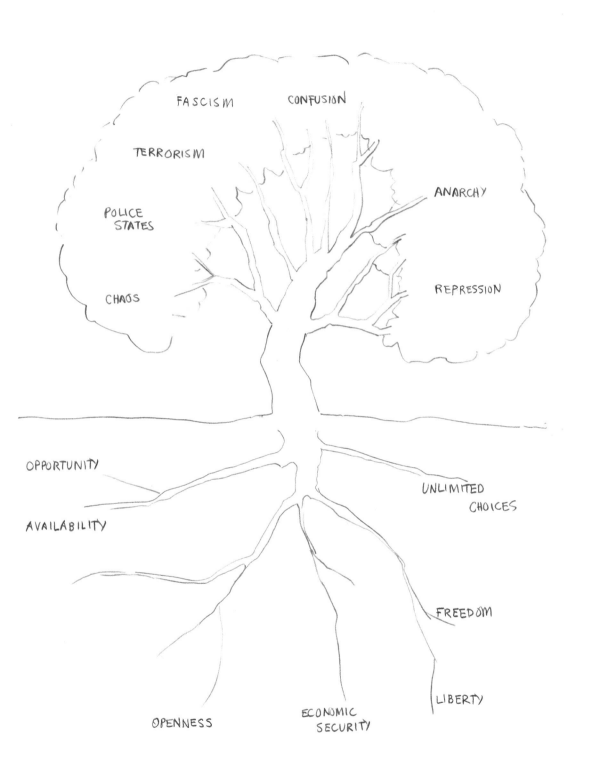

92. Morphological Transformations II

MILITARY DRILLS

RECORD COVERS

PHOTOJOURNALISM

FORMAL GARDENS

MOVIE POSTERS

PROFESSIONAL SPORTS

THEME PARK DESIGN

BALLET

HANDWRITING

GRAFFITI TAGS

MASONIC HANDSHAKES

CORPORATE LOGOS

TATTOOS

HORS D'OEUVRES

RELIGIOUS ICONS

What?

2. Taxonomical Transformations

In D'Arcy Thompson's famous 1917 book *On Growth and Form* he proposed to represent biological evolution as a process wherein over eons one animal can, by enlarging some of its parts and shrinking others, transform itself into another species. In his view this meant that we all have common roots, identical physiologies, but that the elements occur in varying amounts and can morph into different shapes.

He believed that living structures also obey engineering principles just as bridges and buildings do. "The search for differences… [between] animate and inanimate things has occupied many men's minds, while the search for essential similarities has been pursued by few." The borderline between living and non-living might be fuzzier than we think.

4. Pattern Recognition

The dark constellations made by gum on the sidewalk have a logic that is not always apparent to us. Chaos theory and fractal equations help us see the underlying structure in their seeming randomness. In this way, the patterns made by pimples, stains and by accumulated debris are revealed as secret metaphors and algorithms. They are wiring diagrams, instructions, blueprints, printed circuits, street plans and musical scores that we are only now learning how to read.

5. Hidden Roots

Affectionate relationships devolve and disintegrate into distrust and loathing, and possibly the reverse can also happen. The tree could be reversed, and the love we feel in the present could have hate as its hidden aspect. There's a Buddhist saying: "The bigger the front, the bigger the back."

6. Human Content

Snips and snails and puppy dog tails is what little boys are made of, according to the nursery rhyme. Following this metaphorical deconstruction of the young male we can then ask: so what are grandparents, uncles and nieces made of?

7. Morphological Transformations I

The plastic arts—that's what they call painting, drawing, and, of course, sculpture. It refers to creation using any form that can be modeled and molded—and now that also includes the human body. Soon any old person with enough cash to cover the surgery will not only be able to look beautiful, but they'll be able to decide what sort of beauty they prefer: a hairless Barbie doll, a Japanese schoolgirl. As with any fashion, the elite will want to separate themselves from the now merely beautiful hoi polloi; they will choose surgical enhancements based on obscure conceptual and theoretical constructs, much like the fine art they collect. You will have to be in the know to appreciate their beauty; it will be generally unappreciated by the ignorant masses.

Although I don't expect to see live Picasso faces walking around any time soon, I do expect to see cubism's fleshy mirror image: faces and bodies not found in nature that express an aesthetic and philosophy that is refined, elite and obscure.

8. Yes means No

There are ways of saying yes that actually mean no—or at least that convey the negative to the appropriate recipient. These subtle clues are a way of communicating the negative without demanding that the other party lose face by being directly confronted with a no. Foreigners not attuned to these subtle shadings of meaning hear only the literal "yes" and become confused, as I have been in Japan, when the appropriate agreed-upon action mysteriously does not take place. The circle of positive and negative is full of subtle shadings. Every distinction has sub-categories based on mixed combinations—"possibly, but uncertain," for example—and sub-categories within these—such as "doubtful, BUT maybe." Not only that, but the whole wheel is in constant motion, turning and presenting different parts as the top and bottom. A no can eventually become a yes, and vice versa. There is always a reason for hope, but hope could at any moment become despair.

13. We Are What We Eat

In the case of ants this is disturbingly true. Depending on what the grubs are fed, they will grow up to be either a soldier, a nurse, a queen or a worker. The soldier or worker doesn't resemble his diet, but the diet, selected by others, leads the ant genes to express themselves in different ways. This is not a matter of whether or not an individual *might* grow up to be better suited to those professions and corresponding mindsets—this is absolute control, unchangeable inevitability. The food ingested causes irreversible metabolic changes to occur in the slimy little white child, and its future fate is sealed. It either becomes a dwarf who toils away invisibly in the bowels of the colony, tending to the food supplies and the leftovers, or it becomes a single-minded soldier, patrolling the area outside the colony with huge jaws that can get an unmovable grip on just about anything. It not only behaves differently; it is physically different.

Is it really so ridiculous to extrapolate from ants to humans? Our diets are so wide and so varied that inevitably some of us grow up to have quite different propensities as a result. As with ants, the human colony needs all types. If this knowledge of the effects of certain foods were known, probably no mother would choose to feed her child the "bank robber" diet. But the world needs bank robbers, though many deny it, just as much as it needs racecar drivers and real estate developers. Evolution has found a way to make our brains suppress and deny these facts about diet and fate.

17. The Corporate Body

The financial maneuverings and mating behavior of multinational corporations is acted out in miniature by individuals in pickup bars and nightclubs.

18. Gustatory Rainbow

The marketing of new colors for fabrics, house paints and lighting has necessitated the invention of new words to describe these colors. Just as the Inuit have twenty-five words for snow, we have developed more specific descriptions of household paints and laminations. In an instance of acceptable synaesthesia, colors are often described in terms of food: salmon, tangerine, peach. The assumption is that we can

taste colors, that they are either cool or hot, wet or dry, spicy, minty or earthy like a mushroom. Often the name of the color has little to do with the color of the fruit, vegetable or mineral but rather how they feel on the tongue.

19. Morphological Similarities

Salty snacks come in a wide variety of shapes, though most are at least conveniently formed to accommodate the hand and mouth. Do the specific shapes mean anything? Is there significance if a bite-sized piece of salted-baked grain is triangular or square? Or, is it possible that, as with hairstyles, the many variations are there purely for the pleasure of our viewing? Like a bird whose song sometimes announces territory or availability, but sometimes is sung just for pleasure, the varieties of snacks and hairstyles are songs for the eyes and the tongue.

20. Blake's Dilemma

"The road of excess leads to the palace of wisdom." Does William Blake mean that to become enlightened you have to be drunk? Money-obsessed? A sex addict?

There is indeed a high level of bullshit among saints, poets and lovers, which suggests that the skills of con men might be occasionally useful and applicable for loftier pursuits. A con is a work of art and of the imagination, though in the service of cash. But untethered from monetary reward the same skills allow one to float up into the clouds.

21. Economic Indicators

Cause and effect: are they linked in our Western minds because we are addicted to narrative? Because we prefer to believe that things happen in a linear sequence? Because we imagine that narrative only goes in one direction? Quantum theory tells us that there is in fact no direct connection between cause and effect—that instead there are merely statistical odds that one outcome will be the result of something else that has happened. They claim that an outcome is never absolutely certain, even if the odds are pretty good. So, without a direct connection, the flow of causality becomes more fluid, open to possibility, freak connections, magic and the fantastic.

22. Roots of War in Popular Song (Forest of No Return)

A people's aspirations, their fears, and their delusions are clearly manifested in their popular songs. Western pop songs, for example, often deride solitude as something to be avoided, and espouse a can-do go-for-it attitude typical of aggressive and competitive business culture. They encourage the listener to make the business cultural ethos internal, personal. Songs can be read as the public manifestations of things we have difficulty saying to another's face, like "I love you"—and, in the case of conflicts, "I hate you and I will kill your countrymen."

23. The Roots of Consensual Sciences

If a significant number of people accept an idea as being true—and it helps if some of those people are powerful or influential—then it becomes accepted as a fact. Until fairly recently, for example, it was considered a fact that animals did not use tools or possess emotions—those two factors were among the prime means of separating them from ourselves.

However, now those assumptions have been disproved. So much so that you can now almost say that it is a fact that animals both learn tool making and possess emotions.

Economics, a fairly well established "science", might be said to be on the verge of heading the other way—of joining the horoscope readers,

diviners, and psychic healers that lie beneath and outside the realm of scientific acceptability. Economics' principal axiom, that people behave both rationally and in their own best interests, has been disproved time and again in recent years. That leaves the whole "science" closer to magic than it would like to appear.

Therefore, this drawing is actually inaccurate in a sense. The visible area above ground—the area of scientific acceptability and conventional wisdom—is less fixed than it might appear. Things routinely emerge from the earth, the dark chthonic regions, and are accepted as fact—and, just as often, formerly accepted notions lose favor and are viewed as the beliefs of quacks and con men. Branches sink back into the ground and become roots again.

24. Selective Memories
Every sexual relationship adds new things—objects and memories—to one's life that are conveniently overlooked and forgotten as time passes. The tense silent moments, the "foreign" crud in the bathroom and the weird stuff in the refrigerator are not what we associate with romance—but they are certainly a large part of every relationship.

We may choose the sunsets and the wonderful sex, the laughter and shared foodstuffs to keep as mental mementos, and attempt to throw out the ticket stubs, grapefruit peels and wine corks.

But what if it were the other way round? What if stains and hair in drains suddenly took on a bittersweet nostalgic connotation? Imagine the filth that would quickly accumulate in desk drawers, shoeboxes and on little shelves.

25. Various Positions
In some sexual positions the partners all but ignore one another—emblematic of an almost Buddhist approach to an uncaring indifferent universe. The *cuissade* position, for example, could be seen as a philosophical compromise—an acknowledgement of the other, but secretly. One wonders in how in many of the positions can a woman reach orgasm?—maybe none—a situation symptomatic of a biblical philosophical approach in which "man" dominates and subdues "nature". *Ligottage* is the French term for bondage, a kind of desire that manifests philosophically as an extreme form of pragmatism. And lastly, the Viennese oyster refers to a woman who can cross her feet behind her head—an obvious inspiration for the contortionist verbiage of academic deconstructionism.

26. Winnebago Trainspotters
Trainspotting, that peculiarly British obsession with noting the passing of every train, engine number and route, has become the symbol for meaningless obsession with insignificant detail. Other occupations share this extreme focus, but aren't considered as being indicative of borderline insanity. Obsessing over the minutiae of astronomy or literary criticism is socially acceptable, but is just as compulsive and possibly just as meaningless.

Taken to a metaphysical level, this inclination manifests itself as a tendency to fixate on things that cannot be seen or even be proven to exist. Somehow counting and comparing virtual "trains" is spiritual, profound, while spotting real ones is proof that you are loony.

27. Physical Inspiration
Psychology, the talking cure, linguistics, and semantics—they're all like dogs poking around and sniffing their own vomit. There might be some gems in there, you never know. For certain you will at the very least know what you had for lunch. And you can ascertain what not to eat again.

28. Psychosexual Clouds

Almost any defined set—behaviors, objects, names, numbers, colors or sounds—can be mapped onto any other group given a common means of measurement. For example, cloud classifications mapped onto sexual practices and perversions.

First, assume that thoughts and desires have a shape. A physical dimension. A "cloud" of desire is a specific set of neural connections and links that settle over an array of ganglia in a specific region of the brain. For each distinct behavior and desire the net of connections and potential links takes a slightly different form. The nets overlap, but each thought has its own shape. The elongated cirrus-shaped network that touches both the pain centers and the pleasure centers might constitute the "cloud" that is masochism, for example.

We currently classify these desires by their attendant behaviors, but we could just as easily classify them by the shapes of their neural nets, clouds of connections—if we had a way of seeing those, something recent technology is now making possible, and soon these webs will be tangible, almost concrete. Eventually, once the correspondences become familiar, we will associate the clouds in the sky with specific states of mind, ideas, and sexual feelings, not just with puppy dogs, dragons, boats or dead presidents.

30. Becoming Immaterial

Scattered in the wake of sex are songs, socks and longing. And, as the socks get picked up and the underwear is eventually tossed in the hamper, what remains accessible the longest is paradoxically the

most immaterial. What lingers after the tears dry and the smells disperse are the hopes and promises. Out come the corny incanted phrases used like ritual prayers to re-evoke the fading moments, to yank the memory of touch and smell back from the depths where they are slowly sinking beyond reach.

32. Space-Time Reflexivity

If we follow the complexity of lifeforms in a reverse direction, from tapeworms backwards to molds and jellyfish and on to bacteria and viruses, we eventually reach a point where it becomes hard to tell if a thing is truly alive or if it merely possesses some of the same properties as lifeforms. Crystals, for example, grow and multiply, in a sense, and they have structure and even could be said to have offspring. Still, not many have claimed that rocks are alive. But why not? Isn't the border between what is alive and what is not actually fuzzier than we would prefer to believe? And what happens when you go even further back? Well, I sense that, in keeping with Hindu theology, you eventually get to a place that is pure thought and idea. An idea of life, or even simply a notion of materiality. So there you have a kind of life that has no materiality whatsoever.

Also in common with Eastern philosophies is the notion that you arrive at the same immaterial place whether you proceed forward or if you go backwards. It doesn't matter which way you go; you always arrive AT THE SAME PLACE. The ultimate highest ground a lifeform can arrive at and the place before life became material are the same.

The circle is complete—the Gods and movie stars circle back and shake hands with stones, amoeba and bacteria.

33. History of Mark Making

Like a dog pissing on a tree we find it irresistible to leave evidence of our existence in the places we pass. Not only evidence of the fact of our mere existence, but we also feel compelled to leave a record of our thoughts and achievements, our social status, fraternal memberships, loves and fears. These marks originated with bodily fluids—pissing, spitting and the release of semen. Liquids applied by scratching, tearing and disrupting. These sorts of art materials were eventually looked down on as one's status and class rose—any idiot could use his own blood or piss.

34. Roots of Philosophy

The -isms emerge from restlessness; a lusty narcissistic desire to be noticed, admired, justified and propped up by excuses and purely mental rationalizations—elaborate explanations for our nastiness and bad behavior. This, then, is truly what separates us from the apes—the ability to build mental fortresses and battlements to support our selfish and perverted wants. A mighty fortress is my Lord, the Lord of reason, and it could never be otherwise.

35. Audio-Environmental Transformation

Noise is defined as anything that interferes with the transmission of information. Our audio environment is noisy, though the noises are not always loud. The ambient sounds in the background, however pleasant they might seem—birdsongs, rustling leaves or a babbling brook—are noise, no different than the whoosh of traffic on a highway or the static on a phone line. One would think that the louder a noise is the less information can get through, and this is usually true, but it is also true that the ultimate noise is silence, when no information is communicated whatsoever.

36. Granular Synthesis

Freud claimed the subconscious would "speak" through slips of the tongue, snippets of strangely appropriate song lyrics and off-color remarks. But was it not his own dirty mind that always inferred the worst of us? May we not equally reach divine heights of inspiration and inspired metaphor just as often? Is there not just as often a beauty and poetry in slang, lingo, malapropisms and clichés?

37. Acts of God / Acts of Man

The Earth, like the body, needs to be periodically flushed, stretched and subjected to violent cleansing.

38. Nocturnal Organizing Systems

When our normal sleep patterns are disturbed the result is often creativity of a type that requires extreme mental juggling and dexterity. As if the disruption of the relatively calm pathways and routines allows, or forces, the brain to focus intensely, which is what I imagine it takes to play pedal steel guitar—a skill requiring a mind that can keep a series of very complex operations straight while remaining calm. The disruptive emergency calls forth reserves of mental strength, and genius is the result, albeit genius that borders on the obsessively perverse.

40. Household Mutations

A revelation is a sudden, unexpected and not always welcome coming-together of previously known facts not previously connected that then alters our view of things. A paradigm shift

occurs relatively suddenly, as Kuhn hypothesized in his book *The Structure of Scientific Revolutions*. Facts and evidence silently and unsuspectingly build up, reaching a critical point, and then there is a snap, a break, a realignment and a shift in how things are viewed and what is assumed to be true. These new ways of perceiving are analogous to the random accidents and crises we have around the home—we try to make both inevitabilities go away, disappear, but their marks are indelible: the carpet will never be the same.

43. Movement to Gestural Transformation

The energy used in nervous pacing can be effectively squeezed and focused down into the hand, resulting in automatic writing. Sexual movement, one body on another, is both a kind of drawing and a modeling of skin that sometimes manifests, when misplaced, as works of art.

Maybe there is a finite amount of "creative" energy available to each person at any given time—which can either be burned off during sex, exercise or toe tapping. Redirected, it can become a novel or a drawing dense with nervous frustrated cross-hatching. So, just as athletes are advised to refrain from intercourse before a big game, artists and writers should also employ celibacy when they need to refill the creative gas tank.

44. Time Management

We need vacations from our routine in order to make the routine bearable. We know that the ritual of doing nothing is essential.

But what if we take it further? What if we intentionally court unproductive and even wasteful interludes? Would that be even better?

These might result in even more productive lives. We might hope to increase the likelihood of accidents, fostering and encouraging unexpected intuitions and new insights. What if we build chaos into our lives, knowing that it might increase the odds of a creative breakthrough?

45. When Good Lovin' Goes Bad

Our dualistic culture seeks to separate the good from the bad in sexual relationships, but maybe the two are more interconnected and codependent than we would like to think. Maybe shared laughter is a grimace of pain in hiding. Laughter only needs to be pushed a little bit until what was once amusing is no longer funny. Equally, maybe the shouting and arguments witnessed and overheard behind closed doors are signs of intense love. Misunderstandings would never be hurtful if there weren't caring and love there to begin with. So, in a sense, the good stuff makes the bad stuff and the bad stuff is encouraging proof that the good stuff is in there somewhere.

46. Luxurious Transformations

How much of the funds that flow into charities and benefit events derive from a sense of guilt on the part of the givers? Guilt that their income might be slightly undeserved? Guilt and generosity strangely coupled with massive ego and status seeking—for who could imagine a charity event that was quiet and secret? The idea seems to be to publicize your generosity as much as possible, and to thereby accrue some status while doing good works.

So, for every Rolex purchased, some small percentage from the buyer eventually goes

to the arts or to a hospital; for every bottle of Cristal some cash is eventually contributed to a college scholarship fund for disadvantaged children. One could almost encourage conspicuous displays of luxury and status, knowing that they will inevitably lead to generous giving the morning after. The greater the bling, the greater the giving.

(But what about the vast numbers who quietly tithe through their local churches, temples or mosques? The multitudes who can't afford tables at glamorous benefits but give a little anyway, and often, knowing that there but for the grace of God...)

47. Vertical Rhizome

Rhizome root patterns, like those of running bamboo, enable one root system to support many plants. Unlike roots that converge towards one stalk or trunk, in this system the roots are more like an invisible underground network in which the visible evidence can manifest itself in any number of places. Once a network has spread out it is difficult to tell where it began.

Like plants, our lives have a beginning and an end—but one might also view them as a part of a larger information network, with genetic material and DNA as the continuity. Viewed this way, our lives are like plants shooting into view, manifestations of the hidden web that is the genetic sphere—an invisible rhizome pattern. The disappearance of individual bodies from the network out of which they sprang is of little consequence.

48. Flying Blind

The Möbius strip is a surface, which, due to its torque, has only one side—two sides at any single point, but one side if you follow any strip along its length. We can use this to model a loop of a logical thought process: feelings that lead to hunches and eventually become accepted truths and so on, until at some point doubts creep in and a firmly-held belief is subjected to derision—and then eventually we are back to feelings and vague notions, right where we began. Any point on the ribbon is as valid a starting point as any other. Our beliefs and convictions have no other side.

49. Material / Immaterial Metamorphosis

Would I find love if I had not soiled my underwear? I doubt it. My childhood and adolescent traumas shook me up, rattled my brain and gave me the incentive to get out of there. I have to remind myself to be thankful for every tragic embarrassing moment and humiliation. Indirectly, they set me free. [*See Also: 58. The Garden of Eden*]

50. The Performing Arts

All business is show business in one way or another. Even bankers, not known for their wild performances, are "playing" the part of

a banker. They dress and act the part. Every career requires the appropriate costume and every profession carries itself according to prescribed notions of how each "character" should behave. Most people only play a few parts in their lifetime, but a skilled actor will play dozens. [*See Also: 65. Theater of Relationships*]

53. In Vino Veritas

The adjectives most often used to describe wines are two ascending and descending arcs, equated with mental facility. Two nine-point scales connect these arcs, rising up and sinking down in varying degrees of approval or derision. The faculties of the mind and the fruit of the vine.

54. Corpomundonervioso

Nervous tics and habits are (according to Freud) often masturbation substitutes and are their attendant spiritual seed. Scratching and poking. Twitching and toe tapping. Unable to ejaculate real seed by these means, the activities stir up subterranean energies and wind the clock of the ethereal, the wellspring of the creative impulse. The progeny is life, beauty and harmony.

57. New Corporate Galaxies

Adam Smith did not envision private enterprise evolving into a network of unrelated activities. He also didn't foresee the rise of the large corporations and corporate culture. His laws of capitalism are based on a world of crafts, guilds and small industry that no longer exists. For us his laws may as well be derived from a mythical kingdom, one that may or may not have existed but is gone now.

Many of the pinpoints of light that we perceive at night as stars are actually whole galaxies, massive clusters of stars, sometimes thousands of them, all held together by gravity. The new corporate world is likewise composed of companies that, like the galaxies, have no obvious single object at their center. Their constituent members are a variety pak of different businesses, often with very little in common, held together by mere proximity and legal agreement. They are related because they are close, nothing more. They exert a terrific pull on those in their vicinity and on one another to join the galaxy. The urge to consolidate is never-ending, until it eventually passes the tipping point and a black hole is created, at which point the non-existent center truly becomes nothing.

58. The Garden of Eden

It is said that Martin Luther had his insights and inspirations that eventually reformed and radically changed the Christian church during an extended bout of constipation. The Buddha, that formerly spoiled prince, saw poverty and suffering for the first time, went into a depressive state, and as a result began one of the world's great religions. The bottom and the top are closer than we think—which is not to say that depression, anxiety or constipation ALWAYS lead to enlightenment or profound insight. But maybe the reverse is true—that enlightenment is always preceded by doubts and anxieties, and this insight could be triggered by a metaphysical crisis, sexual anxiety or colonic blockage. [*See Also: 49. Material/Immaterial Metamorphosis*]

59. Origin of the Species

Every part of the world is represented in every other part of the world. Parallels and equivalencies abound. The various creatures of the sea, made of jelly and scale and shell, are part of our archaic biological memories—we were once all

of these, and the world we have made is in some ways a reconstruction of this deep memory.

60. Flexibility—Liability

To be flexible, tolerant and open to new experiences is essential to the continuation of the race and the species. Without this labile agility we would have atrophied millennia ago. However, applied and privileged at the wrong time, or worse, at all times, this flexibility can be deadly. There are times when entrenchment and rigidity are equally needed, when a tendency for continual tolerance tips over to become wishy-washiness and fatal indecision.

61. The Subtle and The Physical Body (Male POV)

From many a man's point of view the irresistible charms of women are merely the visible plant that has emerged from a network of tangled, insidious and dangerous roots. Of course, this separation of the visible from the invisible is arbitrary and imaginary—it is a virtual diagram of male paranoia. Paranoia, though usually frowned upon, is in fact a heightened state of awareness—antennae on alert, biological surveillance humming. At moments of danger and risk this heightened awareness and watchfulness is essential. The fact that the object of this male surveillance is imaginary, a mental construct, is beside the point.

62. The Foundation of Pure Thought

Our environment and our world has become filled with a collection of non-spaces—spaces you pass through in order to get to other spaces but which have no identity of their own. Hallways, lobbies, waiting areas.

Over time and with familiarity their NON-identity eventually begins to acquire qualities and textures of its own. The quality of no quality. In this new world without qualities we are inspired to think abstract thoughts—the environments encourage us. Thoughts not anchored to data, scientific verification or solid objects. The floating physical world makes a floating mental world.

63. The Evolution of Category

In the Borges story "The Analytical Language of John Wilkins" he describes a Chinese system of categorization that breaks down the world into Things The Emperor Owns and Everything Else. Claude Lévi-Strauss claimed that one of the most basic categories we humans have is "Can I eat it?" and then, "Do I like to eat it?" The way we categorize and perceive the world is sometimes based on what seem like arbitrary criteria.

For example, there could be intersecting layers of categories: brown things, brown things that are alive, brown things that will hurt me, brown things that make nice pants material. One imagines a kind of plaid semi-translucent three-dimensional Venn diagram representing these categories and their intersections. The number of categories in the world is, therefore, larger than the number of things in the world.

64. Möbius Kiss

Sometimes an imagined and desired object has more substance than a thing itself. Kisses are such nice ephemeral things that they inspire the kinds of loopy möbius-like trains of thought that I'm trying to picture here. Just thinking about kisses throws one into a vortex of

thought and feeling where the inside becomes the outside and vice versa.

65. Theater Of Relationships
[*See Also: 50. The Performing Arts*] …Likewise, the psychologically convoluted relationships we find ourselves habitually falling into parallel theatrical genres. The cruel satire and biting wit of a love affair at the end of its season and the vicious tragedy that is sibling rivalry are acted out as if they had been scripted. We see ourselves in a comedy or a farce, and behave according to our roles. Most of us use the lines most readily available—borrowing from popular songs or sitcoms—and we apply them in everyday speech as the occasion permits.

66. Hutcheson's Moral Senses
The 18th century Scottish theologian and philosopher believed that there was an intimate connection between the perception of beauty and increased morality. The more we see beautiful things, the better people we become. Furthermore, he proposed a hierarchy of beauty, and the attendant moral insights. Imagine then what divine moral creatures museum guards must be! These are his categories, in ascending order. In an attempt to be helpful I have placed appropriate settings and occupations alongside his categories.

67. Dark Roots
The same impulses and imperatives that gave us our sense of beauty and our moral principles also give us the immaterial beings that invade and haunt our consciousness. Leprechauns could be the flip side of the same coin that manifests as good taste—opposite sides, intimately and eternally joined. We can't have a sense of beauty if we don't also believe deep down in fairies. If I call them angels or Orishas the idea

becomes more acceptable—but is there really any difference?

68. Nambikwara Verbal Suffix Categories
According to Lévi-Strauss, the Nambikwara people of the Brazilian plains (Mato Grosso) classified things using suffixes that broke objects down into seven identifiable categories. These suffixes referred to categories such as edible plants, religious fetishes and objects useful in the hunt. Many years and many anthropologists later, new linguistic categories evolved and were added to the language, categories that included the strange new people who had come to visit. The act of being observed and the kinds of observation became new linguistic categories, the watched watching the watchers.

70. Ideological Struggle
Implicit in strip malls' bland packaging of retail opportunity is a belief that everything should be molded, shaped and presented within a clean modular shape. Implicit is a notion that THIS is democracy—in retail consumable form. And in fact it is democracy, for democracy is nothing if not the exercise of the will of the majority, an often ignorant, belligerent, and naïve crowd. In this case their will is brilliantly realized architecturally in the form of strip malls.

71. Military Technology
The need to innovate and invent during war has sparked technological advancements. Cultures benefit from these creative bursts long after the war that funded them has been forgotten. From Velcro to the Internet, our lives have been forever changed by the leftovers of carnage and destruction. The various mechanical devices developed to breach the walls of medieval cities, stripped of their murderous intent, eventually evolved into familiar labor-saving devices and

appliances—their origins long forgotten as they sit calmly on the kitchen counter.

Leonardo's war machine designs:

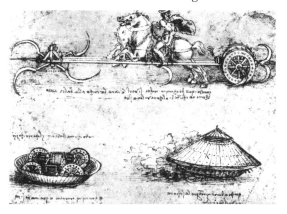

72. Prefixes and Preludes

A prefix changes the meaning of the word that follows it. In much the same way affectionate and flirtatious behavior functions as a prefix, or a prelude, as the Ellington song would have it, to some amorous thing that will follow. Prefixes tell us how to think of that thing that might follow it. In this particular case it makes the thing acceptable. Without the prefix, the word that follows, or the action in this case, might be rejected, refused. The prefix is the glance, the touch or the eye contact that changes how we perceive everything else.

74. Heaven's Cash Register

The effects of poverty and misery can be turned into fashion. From Hell emerges Heaven, and *tout le monde* rushes in.

75. Expressions of Aggressive Behavior

Our aggressive and predatory tendencies, behavior deeply imbedded in our genes, rarely has an acceptable outlet in contemporary society apart from contact sports and "just" wars. However, these impulses leak out here and there in surprising places—in pyrotechnic guitar solos, rude mobile phone manners and Brutalist architecture.

77. Corporate to Personal Homeomorphism

In the 20th century the corporation was legally given, or appropriated for itself, the same rights as human beings. Often, the actual persons involved in a corporation are even, legally at least, superfluous to its existence; the employees and even the president can change, yet it is assumed that the corporation is the same. One way this is accomplished, at least perceptually, is by creating logos and trademarks that stand for and symbolize these corporations. This device exploits our innate tendency to make acronyms and nicknames for people and concepts—making them easier to conceptualize. In German one may simply create a new word by stringing others together to represent a concept—like *schadenfreude* or *gesamtkunstwerk*, two well-known examples that have entered the English language. These put complex entities, like a person or a corporation, in an easily handled conceptual package. Let word grouping X = Feeling Bad on a Sunny Day Because the Sun Shines in Spite of my Personal Disasters. Now we can move X around and juggle it and add it up and multiply it.

Logos and trademarks are merely formalized versions of a conceptual tendency that has been going on for a long time, as long as language itself.

78. Nostalgic Roots of Animal Behavior

Nostalgia is defined as "the pain a sick person feels because he is not in his native land, or fears never to see it again." *Sometimes this occurs in epidemics.*

79. State Formalization of Obfuscation
The laws that govern us, the constitutions and legal precedents, are often little more than elaborate rationales for avoiding the issue of how we shall live together.

81. You'll Get Used To It
There are foods and drinks that make one ask oneself, "How did someone ever first decide that this stuff was edible?" Many things we grow to enjoy (or convince ourselves we enjoy) like beer, vinegar, blue cheese, and vindaloo curries, are downright painful or revolting when first tried. Who or how did someone stumble upon this stuff? Inoculated by social mores we have been taught that pain and suffering are often good for us, that they will improve us—we taste it again, and maybe it's not so bad the second time. Soon enough, we claim (even to ourselves) that we actually like the taste...of the whip.

83. Synaesthesia
Textural adjectives are often used by writers to describe music, though composers for some reason tend to avoid giving instructions using this kind of language. "Brightly, briskly, with feeling," are more commonly used as musical instruction. However, critics often suggest textural metaphors: grainy, jagged, liquid, rubbery. The most commonly described form of synaesthesia is the seeing of colors when specific sounds or notes are played. Mechanical contraptions were even invented to actualize these connections, to make them visible to all, mostly unsuccessfully. Some gifted individuals conjure smells when specific sounds are heard—which can be unfortunate, as sometimes they recoil at the bad odor invoked by hearing someone's name.

Texture, it seems, is a musical metaphor available to all. The senses of touch and hearing seem obviously connected, but what is obvious here is that it is an intuitive metaphor. Oddly, it doesn't work in reverse—one doesn't touch a carpet or gravel road and "hear" music—it only works the other way. It is as if the brain has inbuilt metaphor generators to represent the way music is *organized*, not *to represent* specific pitches or sounds.

85. Wet Philosophy
The elements leading to a romantic or sexual relationship might constitute the roots of some of the more abstract branches of science.